Excellence in Art Education

Ideas and Initiatives

Updated Version

Ralph A. Smith

National Art Education Association
Reston, Virginia

ISBN 0-937652-34-2

First Printing, 1986
Second Printing, Updated Version, 1987

To C. M. S.

Members of the NAEA Committee on
Excellence in Art Education

Acknowledgments

I am indebted to Nancy MacGregor, former president of the National Art Education Association, for asking me to form a committee and to write this essay on their behalf and that of the Association. Thanks are also due to the committee members who approved the initial outline and provided subsequent encouragement and advice. Wherever possible I have incorporated their suggestions, although the responsibility for the contents of the essay is solely mine. I also wish to thank Thomas Hatfield, Executive Director of the NAEA, for his understanding and assistance, the board of directors of the Association for approving the final draft of the essay, and Marsha May for her competent typing of several drafts.

Foreword to Second Printing

Because interest in the topic of excellence in education has not abated and some of the initiatives discussed in the first printing continue to evolve, this second printing updates some of the pertinent developments and literature. This is particularly evident in chapter 5 where under the heading of initiatives for the future the recent report of the College Board, the activities of the Getty Center for Education in the Arts, and the new educational policy of the National Endowment for the Arts are discussed. In addition, a postscript discusses the Carnegie and Holmes reports on teacher education which have appeared since the first printing. I have taken the opportunity of a second printing to improve the text and to correct some typographical and writer's errors. I have further deleted some critical passages while modulating others, and a few of the longer notes have been deleted or shortened. Some new ones have also been added. The general substance of the essay, however, remains unchanged. It is hoped these changes will make this printing even more useful than the first one. I wish to thank Thomas Hatfield, Executive Director of the National Art Education Association, for his continuing encouragement and support, and Selena Douglass for her assistance in preparing copy for this printing.

RAS, Spring, 1987

Note on References

To encourage continuous reading, references and notes are placed at the end of the essay where they are cued to page numbers and identifying phrases.

Excellence

excellence: the quality of being excellent; an excellent or valuable quality; virtue; excellency

excellent: superior; very good of its kind; eminently good; first-class

excel: to be superior to; superior in accomplishment or achievement; to be distinguishable by superiority; surpass others

Contents

1 Excellence, the Continuing Ideal

What the world has admired in the Greeks is the remarkably high level of their originality and achievements, and this high level premises a deeply held conviction of the importance of individual attainment. The goal of excellence, the means of achieving it, and (a very important matter) the approbation it is to receive are all determined by human judgment.

Moses Hadas

Observers of educational trends can understandably be excused for regarding the current national discussion of excellence with some skepticism. After all, it was not too long ago that we were hearing questions similar to those being asked today. Is it possible to have both democracy and excellence? Can not only the most gifted and capable but all youth attain high levels of accomplishment in the various realms of human thought and action? Are the schools capable of designing curricula that will set high goals and expectations while accommodating human differences in background, temperament, and outlook? The questions and the language have not changed. The theme is still equity and excellence.

If there is a difference in the reactions to such questions today, it is largely explained by the decision of the news media to give uncommonly extensive coverage to a number of reports and studies about the schools. A relatively new educational press is also sustaining dialogue and encouraging reform. And fueling such interest is yet another national crisis, this time an economic one. In the sixties the concern for excellence stemmed mainly from anxiety about possible slippage in this country's scientific and technological superiority. Today the interest derives principally from fear about the ability to compete economically with advanced industrial nations. If two decades ago a Russian satellite circling the globe was a spur to

action, today it is Japanese-made automobiles rolling down the ramps of ships in American seaports.

Another difference between the sixties when the idea of excellence enjoyed brief currency and the present decade, especially so far as this essay is concerned, is that earlier discussions centered on improving the teaching of scientific, mathematical, and technical subjects. It was in these fields that the curriculum reform movement of the time was most active. There is still interest in improving the teaching of these subjects, but the discussion today is at least more balanced. A number of studies are recommending a curriculum of common, general education that features not only the sciences and mathematics but also the arts, humanities, and foreign languages. Representative are Ernest Boyer's remarks about the arts in the Carnegie report *High School*. He writes that "the arts are an essential part of the human experience. They are not a frill. We recommend that all students study the arts to discover how human beings use nonverbal symbols and communicate not only with words but through music, dance, and the visual arts." Indeed, a core curriculum of basic studies that goes beyond the three R's, vocational training, and minimal competency is now part of a national discussion of educational reform.

The recommendation to include the arts in a program of general education—that is, as a subject in its own right—is, of course, welcome news to those who have been saying for some time that the arts are important not only because they provide insights into significant human ideas and values, but also because of their capacity to generate qualities of experience that should be part of any full and rewarding life. It is fitting then that the National Art Education Association should acknowledge this new recognition of the arts by sponsoring a contribution to the discussion of excellence in education. This decision contrasts with the situation in the sixties when the literature of the field made only passing reference to the question of quality. At that time theorists of art education, largely under the influence of Jerome Bruner, were more intrigued with the idea of teaching the structure of a subject and what this might imply for a fledgling profession seeking identity and direction. And, in a sense, the questions of art as a subject and its structure are prior, for it is difficult to speculate about the meaning of

excellence in art education when there is uncertainty about the definition of the field itself. In brief, whatever the questions that can be raised about the reports under discussion—and it ill behooves their defenders to dismiss all criticism as simply backlash—they are serving the valuable function of stimulating a renewal of efforts on behalf of excellence.

In the nineteenth century Matthew Arnold cautioned that democracies would experience difficulty in finding and maintaining high ideals and thereby implied that a preoccupation with quality must perennially be on a democracy's agenda. *Excellence in Art Education* reflects this realization, especially in relation to the purpose and place of the arts in American schools. It is really beside the point that the current enthusiasm for excellence will crest, for this essay is meant as much for the future as for the present. It anticipates the next century, the arrival of which will surely be marked by new expressions of hope for a higher quality of life.

While education is not coextensive with the activities of schools and the term "schools" encompasses more than the public schools, this essay mainly concerns the latter. And it concerns not only the public schools of this country, for surely a concern for excellence extends across borders. It was a Canadian novelist, for example, Morley Callaghan, who wrote that the real friends of Canada are those who not only believe in the idea of excellence but who also defend it and try to realize its standards. The ideal of excellence is in truth relevant whenever societies place a high value on the fullest possible realization of human powers, important among which is the capacity to understand and appreciate the human achievement we call art. Artistic and aesthetic values are not ultimate values—rational and ethical values must rank higher—but no account of the good or worthwhile life is complete that does not include a description of the role of art in human existence. Along with language, myth, science, history, philosophy, and religion, art is one of the basic forms of human culture, and it embodies distinctive human excellences.

Once more, the discussion of excellence in education today resembles the period of the early and mid-sixties when the concern for quality stemmed from anxiety about this country's scientific and technological position in the world. Now it is

economic anxiety. It is unfortunate that perennial educational problems receive special attention only when a society's national security and prestige are at stake. Since this is the case, however, those who recall historically earlier commitments to excellence have little choice but to exploit such moments to recall traditional ideals and their continuing relevance.

The recalling of traditional ideals of excellence should be done with an awareness that Americans have never been entirely comfortable with the idea of excellence; its defenders have always had to contend with a persistent anti-intellectualism that Richard Hofstadter described so insightfully in his study of this phenomenon. Anti-intellectualism in this context means disrespect and even contempt for the life of mind and the higher levels of human achievement. Yet traditional democratic ideals place a high value on the indefinite perfectibility of man, a belief which implies that all persons have the potential to transcend their common and ordinary selves in quest of something superior. Along with this belief goes a view that self-transcendence, self-achievement, and self-fulfillment are realized through disciplined encounters with ideas and materials that challenge and motivate individuals to improve themselves. Attainment, in other words, is something wrought through disciplined application and strenuous effort. There is a concomitant obligation to provide opportunities for all persons so to engage themselves, which is to say equity or justice is a corollary of the imperative to excel. That attainment should be recognized and rewarded is another assumption. Doubtless there are things worth doing for their own sakes so that the goal of achieving excellence in them is sufficient motivation, but the desire for intrinsic value is slowly acquired. The majority of humankind require a nudge that recognition produces.

The point of the above is that one does not strive for excellence in general or in a vacuum; one does it within the framework of a society's ideals and with regard to special kinds of excellence. The ancient Greeks first prized the excellence of the athlete and the warrior; then, as the culture developed and became more refined, intellectual, moral, and aesthetic qualities were admired. The Greeks, moreover, bequeathed to later civilizations the idea of *paideia*, a term that refers essentially to the ways in which a society engenders worthwhile qualities of

mind, body, and character. It is testimony to the persuasiveness of the Greek meaning and substance of paideia that our paideia, our problem of education, reveals similarities to the ancient ideal not only in the commitment to individual attainment and its recognition, but also in the belief that excellence takes different forms. Excellence of mind today means more than scientific rationality; it also implies the forms of understanding of the arts and the humanities.

Since not all of the qualities of mind, body, and character to be acquired and transmitted through learning are moral qualities, usage is adopted here that refers to such qualities not as virtues but as excellences. Excellences of mind, moreover, may be understood as dispositions or tendencies to act in certain ways on appropriate occasions. The basic question of this essay thus turns on the dispositions or excellences of mind that should be developed in an excellence curriculum for art education. A complementary question concerns the special value or benefit that may accrue from such dispositions for the individual and for society. Before addressing these matters, it will be helpful to place the discussion in the context of the current national debate on excellence.

The first observation about the cluster of reports and studies in question—for example, *A Nation at Risk*, *A Place Called School*, *The Paideia Proposal*, *High School*, *Educating Americans for the 21st Century*, *Action for Excellence*, *Academic Preparation in the Arts*, *Horace's Compromise*, and *The Good High School*, among others—is that they are a mixed bag. Some are the products of relatively short and intensive periods of research and are in effect little more than political documents intended to ignite reaction, while others took much longer to complete and are of far greater substance. Indiscriminately lumping them together begs questions of their comparative value. It is therefore appropriate that this essay make some distinctions and refer to other studies and publications which, although they were not sponsored by prestigious agencies and appeared in more conventional educational contexts, often have greater substance.

Among the excellence reports there is considerable variance, for example, between the national commission report *A Nation*

at Risk and John Goodlad's multiyear study *A Place Called School*. Also qualitatively different are Adler's brief manifesto *The Paideia Proposal* and the Carnegie Foundation's comprehensively researched *High School*. And there is a world of difference between *Educating Americans for the 21st Century*, which concentrates on improving scientific and technological education, and Theodore Sizer's inherently humanistic *Horace's Compromise*. Somewhat in a category by itself is Sara Lawrence Lightfoot's *The Good High School*. Representative of a current tendency to aestheticize educational observation and evaluation, it presents a number of literary portrayals of purportedly effective schools.

The reports also have some common features, one of which, with the exception of *A Nation at Risk*, is a less alarmist tone than that expressed in past educational critiques. Although the reports are, to be sure, critical of schools, the quality of teaching, and the nature of teacher preparation, there is now greater understanding of the constraints that limit the school's effectiveness. In a new appreciation of complexity, the reports call for more than the revamping of teacher education. They address a large agenda of school problems, including the restraining effects of legislative mandates, the organization of the school day, the mixed blessings of teachers' unions, and the problems of school discipline. In its eschewal of yellow journalism and in its becoming better informed and more realistic about the conditions under which the schools must operate if they are to achieve their objectives, educational criticism shows signs of having matured.

To recall a popular term of yesteryear's educational criticism, in matters of schooling today "entrenched" refers not only to the vested interests of the educational establishment, but also to a number of obdurate and intractable social realities that cannot be talked away with condescending and caustic criticism. Indeed, it is interesting to speculate about the extent to which the kind of criticism that has often been directed at schools and teacher preparation programs has been partly responsible for discouraging reform. Still, the quality of schooling and teacher preparation programs must be a constant concern, and major changes in the preparation of art teachers will be required if art is ever to become a new basic subject in general education. As

we face this task, it is well that yesteryear's ill-tempered criticism is largely behind us.

Once more, although there is the usual concern in the reports about the quality of teacher preparation and impatience with teacher certification procedures, there is also occasional acknowledgment that critics of education are often uninformed about the content and substance of teacher education. Boyer reports what has long been known to educators: prospective teachers take far more courses in the subject-matter disciplines taught by liberal arts and science professors than they do in education or methods courses taught by educators. It follows that if the quality of schooling is substandard today, not only educators are culpable; other faculties of higher education must also set their houses in order. Indeed, higher education itself now has a credibility problem that derives from overspecialization and excessive professionalism, on the one hand, and waywardness, on the other, especially with regard to its loss of nerve in failing to resist the anti-intellectualism of the sixties and seventies. These observations are made not for purposes of increasing the distance between faculties of education and other faculties of higher education, nor, coming from an educator, to be inordinately defensive, but simply to achieve some balance in criticism. Regarding the future of teacher-training programs, the reports are also more equivocal than those of the past. Although some contain the usual recommendations to eliminate such programs altogether, others call for improvements in the current system.

Another characteristic of the reports is their repudiation of freewheeling alternative education and the deschooling of society. Today recommendations for reform tend to propose a general or liberal education for all, high levels of performance and attainment, recognition of teaching talent or exceptional ability, better working conditions for teachers, and more flexibility in organizing and administering schools, not to say greater educational leadership in the principal's office. The private sector, parents, and other groups are encouraged to help. Perhaps because it is now realized that the years of adolescence are at least as critical in educating youth as the earlier years, the reports tend to take the high school as their principal object of

concern. This essay too exemplifies this tendency by emphasizing art education at the secondary level (grades 7-12).

If the reports have their merits, some of them also manifest the limitations of the panel or commission process, which is now the standard way of trying to influence policy. Since the field of art education tends to welcome commission reports from prestigious agencies, a few words are in order about this process.

Taking *A Nation at Risk* as typical, Paul E. Peterson writes that the products of panels, commissions, and multiorganizational ventures seldom receive high marks on either their substance or recommendations. Rather, their principal merit lies in their capacity to dramatize a problem. He further thinks that the schools were already beginning to improve and that the reports are perhaps exploiting, not creating, a trend.

Commission reports further tend to stress only broad and general objectives that provide little specific or practical guidance, a tendency augmented by the fact that panels and commissions lack any authority to implement and enforce the policy recommendations they do make. As a consequence, recommendations are usually impractical and inordinately costly. The lack of substance, concreteness, and applicability is also attributable to the pressure of deadlines and the need of busy people to achieve consensus in relatively short periods of time—an attainment often brought about by sheer fatigue. The added necessity to communicate easily with targeted audiences and the press further makes the limitations of the panel process evident. Anyone who has served on a panel or commission will recognize the aptness of these observations. Nonetheless, because of the high credibility of the agencies and organizations that sponsor studies, the large sums of money spent on them, and the attention studies receive from the media, commission reports can stimulate dialogue that might ultimately lead to worthwhile change. Unfortunately, other substantive studies of education that may contain more cogent analyses and realistic proposals go relatively unnoticed, either because their authors are not celebrities or they do not lend themselves to lively news copy. In brief, in the panel or commission process we see the imperatives of communication in a mass society: things must be short, simple, and dramatic, like a television commercial.

To recall an earlier observation, the reports in question reflect the more conservative mood of the eighties, although the term "conservative" can be misleading. What is meant by the term here is a disposition to think in traditional terms about the value of liberal studies and the ideal of excellence. Such conservatism is an understandable reaction to the assault on traditional educational values experienced during the sixties and seventies, an assault that expressed the outlook and style of the counterculture and was in effect a policy for the systematic inversion of practically all accepted values. To be sure, this same period can proudly boast of the gains of the civil rights movement, of an intelligent concern for the preservation of natural resources and the environment, and, in the curriculum reform movement of the early sixties, of substance in education. What I refer to is the cultural cast of mind of the period—its attacks on tradition and authority and its bent for unbridled hedonism. We have yet to recover ground lost during that period. Important to recall for purposes of this essay were the proliferation of courses in the curriculum and the behavior of many university professors who renounced the prerogatives that experience and expertise in their subjects had rightfully conferred. A misconceived egalitarianism led them to denounce legitimate authority and the appeal to excellence as "uptight" and "elitist." The sixties, then, clamorously supported that tendency toward anti-intellectualism ever present in American life.

The mood today is more Arnoldian; there are appeals to quality and excellence, to the best that's been thought, written, and created. This mood is evident not only in the better colleges or prestigious private schools where excellence has generally been a standard; the best is not too good for Marva Collins's minority children or for those superintendents of large urban school districts who are experimenting with Mortimer Adler's recommendations. The accent on quality is further evident in the program *Push-Excel*, which emphasizes, among other things, the moral authority of the schools and their obligation to nurture excellence in minority students in spite of inordinate odds. The excellence-in-education movement, in other words, has a broad base of support. Groups formerly not on speaking terms are now conversing because of their common motivation to improve the quality of learning.

"Excellence," of course, can be merely a slogan or vogue word, and this use of the term has contributed to the perfunctoriness of many of the recommendations being written by task forces to improve education. If excellence in education is to stand for anything meaningful, it must be defined concretely enough to make a substantive difference in practice. This obligation also derives from other limitations of the reports and studies in question: the high degree of generality that characterizes descriptions of the components of a core curriculum. Such descriptions provide little guidance for organizing the knowledge and skills of core subjects and express only conventional wisdom about teaching; for example, that different methods— didactic, coaching, Socratic—are necessary to achieve different kinds of objectives.

Nowhere is this more apparent than in the reports' discussion of the arts. While it is noteworthy for purposes of this essay that the study of the arts is included in recommendations for a required curriculum, which is to say that at least in policy language the arts have moved from the periphery to the center, almost never is the discussion of the arts inspired or exemplary. This suggests that there is little sense of the preeminent purposes of aesthetic instruction or of the kind of curriculum that is relevant to developing an intelligent understanding of the arts. Although a substantive literature in the field of arts education has appeared over the past two decades, there is scant reference to it in the reports. One study on arts education that was commissioned by the Goodlad study is effectively dismissed with only passing reference, and Adler merely states that making, perceiving, and thinking about art are as important as having knowledge about it. The discussion of an arts program by John Van Dorn in Adler's *The Paideia Program* says nothing that has not already been said more knowledgeably by arts educators themselves. Neither is Boyer's discussion of the arts in the high school very specific; it contains a few words about art as nonverbal communication but nothing about the character of such communication or of the other important functions of art. More helpful are the College Board objectives for art education, but overall the reports are guilty of the very thing of which they accuse the schools: the failure to set clear goals and objectives. They are thus practically useless for thinking about policy for art education.

It has been intimated that in order to appreciate the full import of the reports, more than what they say about the arts must be taken into account. The discussions of teacher education, for example, recommend fundamental changes that would eliminate or radically alter the ways we now prepare teachers. The responsibility for the major part of a teacher's preparation would in effect be assumed by colleges of liberal arts and sciences in which even greater stress than is now the case would be placed on the mastery of subject matter. Only a minimum of education courses would be taken, perhaps during a fifth year or during a period of apprenticeship. It doesn't matter that some of these recommendations reflect long-standing prejudices on the part of certain writers and groups against educators and colleges of education and the influence educators have, or even that discussions often reveal little knowledge about how teachers are actually prepared. The recommendations are being entertained. It is only common sense then to perceive the reports' entire agenda of reform. It would be unwise in the extreme to endorse a report that, if fully understood, would effectively weaken the authority of one's chosen profession and perhaps put oneself and one's colleagues out of work. Art educators who read the reports in their entirety should thus feel ambivalent. Both Boyer's *High School* and Adler's *Paideia Proposal* strongly recommend the study of the arts as part of a core curriculum, in terms, moreover, that will ingratiate the authors with many art educators. Yet, Adler's well-known negative attitude toward educators, and that of the group on whose behalf he writes, will quite understandably affect the disposition of many educators to entertain his proposals. Boyer's recommendations, on the other hand, would, if implemented, put an end to current practice in the undergraduate training of art teachers. Lest there be any misunderstanding, the status quo is not above criticism. Indeed, the last section of this essay suggests a major reorganization of the way we prepare art teachers for the secondary grades. There has, moreover, been serious criticism of education and teacher preparation by educators themselves (though one gains little sense of it from reading the reports). The point is that in several respects the reports question the conventional idea of a profession of education, and educators, including art educators, should at

least ask themselves whether they are willing to abandon that idea or how they can uphold it while making some obviously needed changes.

What can we conclude from the foregoing? After one takes all relevant considerations into account—for example, the media's dramatization of the reports, the persistent prejudices against educators, the deficiencies of the panel process, and the revolutionary recommendations for teacher education—the fact remains that the reports have the virtue of recalling the traditional ideal of humanistic education that owes nothing to social expediency, liberal or conservative political opinion, or technological and economic competition among superpowers. Some years ago the literary critic Lionel Trilling asked whether there were any conditions in the society that favored the retention and revival of this humanistic ideal—that is, the achievement of self-definition and self-realization through disciplined encounters with the best that has been thought, written, and created— and he concluded there were few grounds for optimism. Knowing, however, that American thinking about education is prone to extreme pendulum swings of opinion, Trilling withheld a wholly pessimistic conclusion. The mood today represents just such a pendulum swing, this time in favor of making substance, standards, discipline, and excellence principal concerns.

Before the study of art can occur in a core curriculum of general education, it is necessary to formulate a defensible idea of art, to explain in what its peculiar excellence consists, and to indicate how the schools can develop an understanding and appreciation of such excellence. Once again, the reports offer little help on such questions, and the problem is compounded by differences of opinion in the field of art education.

A few final comments. Up to now, the term "arts education" has been used in a general way, but henceforth, unless the context implies otherwise, "art" and "arts" will usually refer to the visual arts of painting, sculpture, graphic art, film, and architecture. The selection of various visual art forms for study, however, still leaves open the question of study sequence and method of presentation. One should not expect tenth-graders to plumb the mysteries of Neoplatonism reflected in Renaissance art or to grasp the meaning of Existence philosophy as it qualifies twentieth-century images of human alienation. Yet it

would be a serious mistake—and this must be emphasized—not to feature in any discussion of excellence in art and art education justly famous masterpieces and classics of the visual arts, works which themselves have set the standards for artistic excellence. At appropriate times young people should become acquainted with works of artistic greatness and with the reasons for ascribing such stature to them.

It says something about the state of our culture today that such a recommendation cannot assume acceptance and is in fact often condemned as elitist. To be sure, the belief that the study of the classics represents an undemocratic imposition of elitist standards is misleading for several reasons, but its persistence occasions the discussion of elitism in chapter 4. Here it is sufficient to agree with Aristotle, who held that true happiness and the good life consist of activity in accordance with the highest excellence; with Goethe, who believed that in matters of art simply the best is good enough; and with Matthew Arnold, who likewise encouraged recourse to the best knowledge and ideas of one's time in pursuing perfection. In short, an impressive chorus of voices from the past and present sings in praise of excellence.

What now shall we mean by excellence in art? What concept of artistic excellence should inform the designing of an excellence curriculum for art education at the secondary level?

2 Excellence in Art

> Works of art can, at their best, extend the perceptive faculties to the full without satiation and as it were demand ever increased mental vivacity and grasp to contain them Years of study and experience, half a lifetime of growing familiarity, may contribute to the full appreciation of a great work of art; the experience itself is always accompanied by a feeling of heightened vitality; we are more awake, more alert than usual, the faculties are working at greater pressure, more effectively, and with greater freedom than at other times, and the discovery of new insights is their constant guerdon.
>
> *Harold Osborne*

Therein lies the peculiar excellence of art: its capacity at its best to energize experience in special, worthwhile ways. Such experience has both affective and cognitive strands; feelings intensify at the same time as insights accrue.

Such a characterization of art's power to stimulate experience comports well with this essay for a number of reasons. It first of all reflects ideas writers have articulated throughout the history of thinking about art and its effects and thus has the value of maintaining continuity with the past. Classical writers were quite aware of the peculiar energies and potencies of art, as were eighteenth-century German and English philosophers who framed the modern notion of aesthetic experience. And some major twentieth-century theorists have refined the thesis that the preeminent function of art is to give a distinctive character to human experience.

A view of art that sets store by its capacity to affect human experience in worthwhile ways also gives point and direction to the enterprise of art education. In addition to intensifying and clarifying awareness, an excellence curriculum initiates the young into what Ernst Cassirer in his classic *An Essay on Man* calls the circle of humanity, which includes not only language,

myth, religion, philosophy, history, and science, but also
art. Modern educational theory in effect follows Cassirer's
lead in assuming that a major obligation of the schools is to
introduce youth to multiple forms of human comprehension,
variously termed ways of knowing and experiencing, disciplines
of thought and action, realms of meaning, forms of understand-
ing, symbolic systems, multiple intelligences, and forms of
representation.

Initiation into the form of awareness peculiar to engaging art
in turn suggests content for art education, for a capacity to
appreciate artistic excellence presupposes that appropriate dis-
positions have been fashioned from a mastery of relevant con-
cepts and skills.

Finally, if defining excellence in a certain way helps to de-
lineate the contours and suggests the content of art education,
the distance between partial and full appreciation helps to set
limits to the schools' responsibility. Noting Osborne's remark
that familiarizing oneself with a masterpiece may take half a
lifetime, the purpose of aesthetic instruction can be stated as
the equipping of learners to undertake initial voyages in the art-
world, a preparation that will enable them to encounter works
of art with discerning awareness and discriminating judgment,
just as, ideally, a science curriculum equips learners with the
necessary dispositions to cope with scientific phenomena.

Put in the terms of this essay, *the general goal of art educa-
tion is the development of a disposition to appreciate the
excellence of art, where the excellence of art implies two
things: the capacity of works of art at their best to intensify
and enlarge the scope of human awareness and experience and
the peculiar qualities of artworks whence such a capacity
derives.* The remainder of this chapter addresses these two
senses of excellence.

Many introductory textbooks on art reproduce a range of vis-
ual objects capable of arousing and stimulating human response:
not only paintings, sculptures, graphic art, photographs, and
frames from film, but also works of architecture, objects of
industrial design, posters, advertisements, and cartoons. Excel-
lence has been achieved in all of these forms of visual art, for
one of the meanings of excellence is excellence within kind. But

this is not the sense of excellence intended in Osborne's remarks at the opening of this chapter or in this essay. In an excellence curriculum we are concerned with the more complex or higher levels of excellence in visual art, so that it would be improper to speak, say, of the excellence of a stop sign in the same tone we use in speaking about a fifteenth-century master drawing or a serious film. Given, moreover, the constraints of available curriculum time and the obligation to maximize learning, we must make choices among possible candidates. This essay finds a principle of parsimony, that is, a way of reducing the number of things to study, in the idea of excellence as a special potency of a work of art to affect human experience in worthwhile ways. In respect of this potency, some works of art will be more excellent than others; they will have greater potential for extending and enlarging perception. Among innumerable test cases we may take Michelangelo's justly renowned sculptures in the New Sacristy in S. Lorenzo, the Medici church in Florence. That they have a far greater capacity to occasion worthwhile experience than does, say, common-variety mortuary statuary is a fact beyond reasonable dispute. And the reasons are readily apparent; Michelangelo's works stand out in virtue of their powerful presence, technical brilliance, formal complexity, and symbolic expression, features that compel and sustain response. The seated figures of Lorenzo and Giuliano de' Medici and the reclining allegorical figures of Dawn, Day, Dusk, and Night are thus unquestionably superior instances of artistic excellence.

So much may seem obvious except for the fact that in contemporary discussions of art education a principle of selection that stresses excellence in the sense discussed in this essay is, once again, often termed elitist. It is believed that an emphasis on quality represents an unjustifiable imposition of traditional aesthetic values on persons—particularly members of the working class and ethnic groups—to whom such values are purportedly irrelevant. An excellence curriculum for art education is thus forced to defend itself against the charge of elitism. This is the task of chapter 4, although its thesis may be anticipated here by saying that there is nothing undemocratic, snobbish, or elitist in wanting to acquaint young minds with some of the greatest achievements of the human race, with pointing out to them the pinnacles of human artistic accomplishment.

To be sure, an excellence curriculum for art education should consist of the study of more than traditional masterpieces from the Western tradition. Artistic excellence is found in all cultures and civilizations. So long as the accent is on quality and the first-rate, on excellence as characterized in this essay, there is no reason to disqualify the art of any group, society, or era. But, once more, there would be something perverse and seriously remiss if an essay on excellence in art education did not mention the works that constitute our own cultural heritage, works that are the very touchstones and exemplars of artistic achievement and which for centuries have established the criteria for excellence in the arts. Such works are found in any standard history of art and include both the major and the minor arts, that is, vases as well as paintings (and paintings on vases), tapestries as well as monumental sculptures, and domestic as well as public architecture. While the list of key monuments remains relatively stable, it is not immune to revision, which is to say the history of art is as subject to self-correcting scholarship as any other area of study.

Not only have the great artistic works of the past set the standards for much of subsequent artistic creation and art criticism, they continue to challenge artists in their efforts to forge new sources of aesthetic value. They also influence thinking about life in general. When John Dewey wanted to dramatize his vision of unified experience marked by consummatory value— that is, experience enjoyed for its own sake in part because of its minimal disjunction between means and ends—he turned to art for a model. There is in fact a significant tradition of aesthetic and cultural thought dating from Friedrich Schiller's *On the Aesthetic Education of Man* and running through Herbert Read's *The Redemption of the Robot* to John Dewey's *Art as Experience* that speaks persuasively (though no doubt a bit too optimistically) of human existence approximating the forms and qualities of art.

These rather obvious points are underlined because the field of art education is still gripped by the belief that children's art should be at its center and that instruction in the form and dynamics of children's artistic creations should not only form an important part of a prospective teacher's training but also be the principal concern of research. The question, however, is not

whether young people should learn to make things; it is toward what end they should be taught to do so. Time should not be spent in instructing students to make things if this is done solely because such activity is intrinsically enjoyable or a form of self-expression that might perhaps incidentally foster creativity. The primary purpose of teaching students to manipulate the material of art is to help them acquire a feel for artistic design and to grasp ideas that will serve them well in their future commerce with art—in short, to cultivate in students an educated capacity for the appreciation of artistic excellence. Pursuing other goals would commit art educators to a questionable way of thinking about their field. We do not, for example, speak of children's science, children's mathematics, or children's geography; rather, we speak of the ability of children to understand these subjects at a level of difficulty commensurate with their intellectual development. If a comparable attitude were encouraged in art education, one would hear less talk about "children's art." Instead, art educators would acknowledge that *the purpose of art education is to teach young persons to appreciate excellence in art, which implies that pedagogical efforts should center on achieving this principal goal.*

Although there is increasing acceptance of this view of art education in the literature, the continuing strength of the opposite position—i.e., that art education should be mainly about children's art—prompts underlining what otherwise might go without saying: until mature art itself is made its subject, art education will have difficulty becoming a serious course of study in the curriculum of the schools.

We are beginning to realize, moreover, that children's interests extend beyond things of their own making. A number of studies indicate that young children can become quite interested in the works of mature artists. Their talk about art reveals an unsuspected range and diversity. Common sense thus suggests that constructive activities should be supplemented with appreciative ones. One might not think, for example, that elementary school children could develop any notable interest in, say, Renaissance art of the fifteenth and sixteenth centuries; the world of that art is too remote from the world young people inhabit. In many ways, of course, it is; but we tend to forget, doubtless because art history is not a prominent part of

the training of a public school art teacher, that the content of Renaissance art consists of far more than complex religious and philosophical symbolism. It is also full of action, spectacle, and adventure. Nor were Renaissance artists averse to depicting the various moods and guises of young people themselves. In short, neither the sensory qualities nor the content of much traditional art is necessarily lost on the young. We are, of course, speaking of a rudimentary and not a full appreciation of mature art; but there is no reason to think that works only partially appreciated at one time cannot be reencountered later on, perhaps within the context of what Bruner calls a spiral curriculum. The problems of art education for the elementary years, however, are not the principal concern of this essay. They are referred to briefly because attitudes and practices appropriate for the early years tend to be carried over into the secondary grades. What now, more specifically, do we mean by the excellence of art?

The Excellence of Art

Recalling that we are speaking of the excellence of art as both the capacity to affect human experience in special, desirable ways and the artistic and aesthetic qualities whence this capacity derives, it must be pointed out that throughout history what has been considered worthwhile has usually been a function of a work's particular purpose. Since prehistoric times art has performed a plethora of functions which have been studied and documented by investigators with diverse interests. Historians trace the evolution of art, interpret its meaning, and classify it into period styles. Philosophers speculate on the import of art in the life of man, attempt to grasp its essence, and try to clarify its basic concepts. Social scientists study the interdependence of or disjunction between art and society. Psychologists probe the dynamics of artistic creation and appreciation. The reasons for art and for studying it are legion, and theories of art have accumulated to such an extent that we are now beginning to get theories of theories. The point is that the complexity of art and its numerous functions caution against facile generalization.

To reiterate: one way to think about excellence in art, a way

that acknowledges art's true complexity, construes excellence as the capacity of art at its best to occasion worthwhile experiences and the qualities and properties whence such a capacity derives. This means the task of discussing the excellence of art has two parts: a description of the kind of worthwhile experience afforded by works of art and a description of the special properties and qualities of artworks responsible for stimulating such experience.

Art and Worthwhile Experience

Before describing the capacity of art to provide worthwhile experience, it will be helpful to pause and remark briefly on the kind of topic under discussion. The description of human experience from any point of view is extremely difficult. The characterization of what Abraham Maslow once called the farther reaches of human nature—its creative, imaginative, and spiritual peaks, for example—is perhaps the most difficult of all. Because these realms of human experience are highly intractable to inquiry, we must be prepared for a certain vagueness in descriptions that try to capture their nature. Now this may be just one more of those things that should go without saying were it not for the fact that it is occasionally forgotten even by students of the arts and humanities, art educators among them. The paradox is sometimes remarked that graduate students, who are presumably drawn to the field of art education by a cast of mind that inclines them to appreciate the dramatic in human experience and the nonliteral renderings and interpretations of things found in art, are encouraged to undertake rigorous scientific research for their advanced degrees. These students are victims of the fallacy of misplaced exactitude, the error of looking for precision in the wrong places. As Jacques Barzun (following Blaise Pascal) might say, they are encouraged to cultivate the spirit of geometry when they should be cultivating the spirit of finesse.

What is true of describing human experience is also true of describing such complex things as works of art, of attempting, for example, to characterize their status or identity, their qualities and meanings, and their value or worth. There is a further consideration. Discussions of human behavior and art

take place at different levels. At one level we find the discourse of frontier inquiry in which scholars examine ideas and hypotheses in technical or quasi-technical language. Confusion results when no effort is made to translate technical language into terms more readily understandable, and the problem is compounded when the same terms function in both technical and nontechnical contexts. This is often the case in talking about art and related topics. Medium, form, content, style, representation, expression, and aesthetic quality are all terms found in technical and nontechnical contexts and often mean different things in different theories. John Hospers, for example, has pointed out at least four different senses of artistic expression: artistic expression as artistic process, as aesthetic qualities, as meaning, and as emotional arousal. But we need not multiply examples. In the discussion of art and worthwhile experience to follow, certain terms are used whose meanings depend on the contexts or theories in which they occur. "Aesthetic experience" is one such term. It is found in both technical analyses of the concept and increasingly in ordinary parlance. In talking about art's capacity to afford worthwhile experience, leads will be taken from technical discussions of the concept, but whenever possible ideas will be translated into less formal terminology. It will also be apparent to readers familiar with aesthetic theory that in trying to explain art in terms of the worthwhile experience it can provide, this essay draws on John Dewey's *Art as Experience* and on recent accounts of aesthetic experience which have attempted either to refine Dewey's formulation or simply to set out the concept.

If the worthwhile experience afforded by a great work of art is a full-bodied one of some complexity and magnitude, then, obviously, not all visual phenomena can occasion such experiences. To be sure, those moments in the flow of life in which we pause to enjoy such things as the quality of light at dusk, the freshness of spring cover, or the starkness of winter forests provide some aesthetic satisfaction. The level of experience doubtless rises when a temporal dimension is involved, as in, say, watching falling leaves and the setting sun. A finely tuned imagination can also find much to admire in contemplating urban vistas and objects of ordinary use. For example, here is the Russian painter Wassily Kandinsky on Moscow an hour before sunset:

Pink, lavender, yellow, white, blue, pistachio green, flame-red houses, churches—each an independent song—the raving green grass, the deep murmuring trees, or the snow, singing with a thousand voices, or the allegretto of the bare branches, the red, stiff, silent ring of the Kremlin walls and above, towering over all like a cry of triumph, like a Hallelujah forgetful of itself, the long, white, delicately earnest line of the Uvan Veliky Bell Tower. And upon its neck, stretched high and taut in eternal longing to the heavens, the golden head of the cupola, which is the Moscow sun amid the golden and coloured stars of the other cupolas.

And here is the late L. A. Reid, the English aesthetician and philosopher of education, on something so simple as a shallow-bowled spoon. He writes that

the lines are smooth, easy, liquid, flowing, the handle is deliciously curved, like the tail of a leopard. And strangely, without contradiction, the leopard's tail is finished with little raised nodules like small grapes. It is a queer mixture of a leaf and a leopard. The texture is grey and dull like river mist, and it is lit with soft lights shining out of it like the moon out of a misty sky. The sheen is white-grey satin: the bowl is delicately shaped with over-turning fastidiously pointed fronds; it is restrained and shallow, yet large enough to be generous. The lines are fine and sharp with clear edges. Thus described, such a concatenation of qualities may sound absurd and incongruous. But if you hold the spoon in your hand, you feel it as a kind of poem which in a strange way unites all these, and many other, values into a single whole. You feel as you see it that you are living in a gracious world, full of loveliness and delight.

Perhaps a utensil has never been described so affectionately, and Reid's account reminds us that appreciable aesthetic value can reside in objects of practical use. But there is a world of difference between the fineness that Reid finds in his spoon and that found by Meyer Schapiro in his description of the qualities of one of Cézanne's interpretations of Mont Sainte-Victoire:

It is marvelous how all seems to flicker in changing colors from point to point, while out of this vast restless motion emerges a solid world of endless expanse, rising and settling. The great depth is built up in broad layers intricately fitted and interlocked, without an apparent constructive scheme. Towards us these layers become more and more diagonal; the diverging lines in the foreground seem a vague reflection of the mountain's form. These diagonals are not perspective lines leading to the peak, but . . . conduct us far to the side where the mountain slope begins; they are prolonged in a limb hanging from the tree.

It is this contrast of movements, of the marginal and centered, of symmetry and unbalance, that gives the immense aspect of drama to the scene. Yet the painting is a deep harmony, built with a wonderful finesse. It is astounding how far Cézanne has controlled this complex whole.

Though notable for its aesthetic qualities and deep harmonies, Cézanne's art does not invite interest in human significance in quite the same way that many of Pablo Picasso's works do, for example, his famous mural the *Guernica*, here described by E. F. Kaelin:

When we respond to a shape as a representation of a bull or horse, our experience deepens: more of the world is now includable within our brackets. If we look more closely, we can identify other objects: a broken warrior, frozen in rigor mortis, his severed arm still clutching a broken sword; a mother in agony over the death of her child; a woman falling through the shattered timbers of a burning building; a flickering light; a wounded dove, its peace gone astray. . . . Let the mind play over these images and an idea grips the understanding: the wages of war, as it is currently conducted, are death and destruction. . . . So interpreted, our experience of *Guernica* deepens and comes to closure in a single act of expressive response in which we perceive the fittingness of this surface—all broken planes and jagged edges in the stark contrast of black and white—to represent this depth, the equally stark contrast of the living and the dead, the flickering of the light repetitive of the condition of those flitting in between.

With Cézanne and Picasso we arrive at the end of our spectrum of things having the capacity to induce aesthetic experience. Is it possible to abstract from these aesthetic descriptions, and many others like them, common features that will give us a notion of the characteristic kind of experience afforded by art at its best? Precisely such an effort has been attempted by the late Monroe C. Beardsley, whom Nelson Goodman once called the dean of American aestheticians, and Harold Osborne, who may be called Beardsley's British counterpart. Beardsley thinks that our characteristic experience of art and comparable aesthetic objects tends to have five features, though not all of them must be present on every occasion of aesthetic experience. These features are object directedness, felt freedom, detached affect, active discovery, and personal integration or wholeness.

In language less formal than that we tend to find in scholarly

discussions of the topic, we may say that our experience of art often involves a temporary suspension of practical preoccupations in favor of an inclination simply to dwell in the unique world of a given work of art. As dwelling in the world of a work is an intense living in the present, extraneous thoughts about the past and future are largely absent from the forefront of consciousness. Whatever thoughts, memories, and associations do surface during perception are controlled by the work itself and the point of view that the observer is taking toward it. Submission to the work and to its qualities and meanings is undertaken freely for the sake of whatever delights and insights the work itself affords. The viewer seldom has any ulterior purpose but that of experiencing the work in its fullness. Since, however, we experience a work of art at a certain emotional distance—that is, we do not mistake the representation of reality for reality itself —and since we are aware that we are confronting something specially contrived for our perception, the feeling tone of the experience of art is different from that of mere impulsive outbursts of emotion. It is difficult to find a term that adequately captures this feeling tone—again we are attempting the description of what is inherently vague—but the notion of detached affect comes close, or what is sometimes called the detachment of involvement. The point, as Osborne emphasizes, is that the exhilaration of experiencing art is less a function of feeling being directed inwardly than it is of its being directed outwardly toward the object of art. The fact that we experience a work of art at a certain emotional distance further helps to explain why perception can accommodate without undue disruption of attention the dark and tragic aspects of life, such as the contents of Picasso's *Guernica* or Goya's depictions of the cruelties of war.

Given the intense concentration required to perceive an excellent work of art, the viewer's receptivity to artistic complexity for its own sake, a free yet disciplined and controlled enjoyment, and the challenge to make disparate phenomena cohere into a unity—given, that is, the drama of experiencing a work of art—it is not surprising that a feeling of active discovery and exploration is also counted as a feature of aesthetic experience. The object of such exploration and discoveries are not only formal and expressive qualities, but also meanings. Now, if

it is reasonable to hold that human mental powers become animated during our experience of art in the ways just described, if, that is, perception, reason, and feeling are energized in the manner indicated, and if vision becomes uncommonly synoptic and comprehensive, then it seems acceptable to suppose that our experience of art, unlike our experience of most other things, contributes to a sense of personal wholeness or integration. We experience a state of well-being noteworthy for its being unmarred by the discontinuities and frustrations of everyday living. If our experience of art can be all of this, then surely we are entitled to say of an encounter with an outstanding work of art that it was *an* experience, in the Deweyan sense. In this respect, the experience of excellence in art features the values of concentration, connectedness, freedom, and exhilaration against the disvalues of aimlessness, fragmentation, constriction, and frustration. If, once again, we think of observers of art as voyagers in a unique world, we can imagine such travelers returning from their experience of works of art revitalized by perceptions of new qualities and a fresh awareness of familiar ones, not to say new and refurbished meanings—in short, by new perspectives on art, the world, and self.

We have now characterized excellence in art as a capacity to occasion worthwhile experience. We have further explained such experience as a function of an outstanding work of art and a special point of view taken toward it.

It is a tribute to the powers of artworks, however, that their overall excellence or excellences, which is to say once again their capacity to occasion worthwhile experience, can extend beyond the energizing of intrinsic perception. As intimated, it is reasonable to assume that a well-cultivated disposition to appreciate excellence in art can affect a number of other important human values. Works of art can stimulate not only aesthetic percipience, but percipience generally. Accordingly, we may notice subtleties and nuances in numerous contexts. Works of art may furthermore be assumed capable not only of engaging the aesthetic imagination but also of stretching imagination generally. Once again, a defensible way of thinking about the possible secondary effects of our transactions with works of art is that repeated experiences of artworks can strengthen and reinforce other human values. But it is a serious misconception

of art education to think that the use of the arts to stimulate nonaesthetic learning outcomes, such as reading or mathematics objectives, is an acceptable substitute for developing an appreciation of artistic excellence; there is no substitute. Policymakers also delude themselves if they suppose that the arts can be a significant catalyst for general school reform. We should not use the arts to try to change schools; rather we should design curricula in which art is a valuable subject capable of yielding important and distinctive results. Crude, instrumental conceptions of art education are in truth anti-art. In no small measure, then, an excellence curriculum can be both an antidote and an alternative to certain ideas of art education that were popular in the sixties and seventies, ideas that, astonishingly, were underwritten by a number of prestigious agencies and organizations and uncritically endorsed by art educators.

In other words, this essay is *not* saying that art education should be committed to a view of "art for art's sake." We seldom value anything for *its* sake but for the sake of the use to which we can put it, even if that use is a relatively nonpractical one such as aesthetic contemplation. Nor is it being said that art should be studied mainly for its intrinsic values, for such terminology is ambiguous. It is more accurate to say that we value certain qualities and properties of art for their instrumental capacity to induce worthwhile experiences, and that such experiences are valuable not only for the ways they energize and enlarge aesthetic perception but also for the ways they can strengthen other human values. The benefits of the immediate experience of art are the features of aesthetic experience discussed earlier in this chapter, that is, feelings of felt freedom, active discovery, and detached involvement; these may be called the *proximate* or more immediate and direct benefits of experiencing art. The human powers that may be the beneficiaries of aesthetic experiences, for example, general percipience and imagination, may be called the *prospective* values of art. Such terminology centers attention on what is important about art —its uniqueness and relation to life.

Before moving on to the next section, we should pause to remark that while the discussion of art and worthwhile experience has been largely positive in character and implies that art

at its best has the potential to contribute to individual and
social well-being, the beneficial effects of art should not be
heralded without acknowledging some of its potential disvalues.
The uncommonly persuasive and captivating power of art may
occasionally beguile us into withholding judgment on some of
its questionable aspects. The aestheticizing of violence in films
is a good case in point; the personal attractiveness of protag-
onists and the hypnotic power of the medium may soften atti-
tudes toward morally repugnant acts and in effect condone
them. On another level of analysis and criticism the question
has even been asked whether there is a covert correlation be-
tween aesthetic sensitivity and human cruelty, a concern arising
from the observation that cultivated aesthetic sensibilities have
often failed to deter the commission of crimes of inhumanity.

Apprehension about the potentially harmful effects of art
has, of course, a tradition that dates back to antiquity. Today's
rather pervasive worry that art may not be good for us suggests
the need to build a safety valve into our commerce with art. It
is no longer sufficient merely to develop a capacity to appreci-
ate excellence; we must also develop a disposition to reflect
critically on the contents of our experiences. What is wanted is
not just aesthetic percipience but *reflective* aesthetic percipi-
ence. A reflective aesthetic percipient not only takes the aes-
thetic measure of a work but assesses its contribution to what
George Steiner calls a humane literacy—Steiner being our
modern mentor in these matters.

Having mentioned the need for a safety value in our experi-
ence of art, we nonetheless should keep in mind that to adopt
the aesthetic point of view toward a work of art is after all to
seek out a distinctive source of value, namely aesthetic value.
The cumulative effect of experiencing harmonious design, good
proportion, and intense expressiveness—all marks of aesthetic
value—is not an enervating hyperaestheticism or paralysis of the
will but, writes Beardsley, an "increased sensitization, fuller
awareness, a closer touch with the environment and concern for
what is and might be." It is doubtful, he thinks, that "we could
have too much of these good things, or that they have inherent
defects that prevent them from being an integral part of a good
life."

Quality in Art

The remainder of this chapter centers on some of the particular excellences of art and lends the preceding discussion more concreteness. Such excellences have been conveniently discussed in a number of recent volumes and essays that address the topic of quality in art.

With the intention of discovering to what extent the criteria of excellence in past and present art have substantial objective referents, Jakob Rosenberg, in his impressive *On Quality in Art*, compares a number of master drawings and prints by major and minor artists from the fifteenth century to the twentieth—from Martin Schongauer and Leonardo and their schools to Picasso and Kandinsky and their lesser contemporaries. Rosenberg limits his study to drawings and prints because qualitative differences in these arts are both easier to detect and reproduce, but he thinks that with appropriate qualifications the same qualities can be found in painting, sculpture, and the decorative arts. The works Rosenberg analyzes include examples of both representational and nonrepresentational art. What are his conclusions?

It comes as no surprise when Rosenberg says that the quality of formal organization is highly important in both representational and nonrepresentational works of art. Even though nonrepresentational works lack subject matter, they nonetheless manifest such important qualities as inventiveness, originality, suggestiveness, economy, and gradation and integration of design. Both kinds of art, moreover, reveal sensitivity, articulateness, consistency, selectiveness, vitality, range of accents, richness of formal relationships, intensity, expressiveness, sense of balance, and a feeling for the medium. Such qualities, says Rosenberg, constitute the artistic value or degree of excellence of particular works. Far from being expressions of personal opinion, such judgments reflect the consensus of aesthetically intelligent observers.

Two examples from the seventeenth and twentieth centuries convey the flavor of Rosenberg's method. Commenting on a drawing titled *Lamentation* by Rembrandt and a copy attributed to Rembrandt until the original was discovered, Rosenberg writes that "one can easily see that the copy, done in pen over

pencil, is only a meager skeleton of Rembrandt's pen and wash sketch." Among its other qualities, the Rembrandt drawing has "enormous richness," achieved mainly through the variation of tonal accents and their interrelationships. Such accents and relations contribute not only to the clear suggestion of forms in space and their envelopment by light and air but also to the sensitive expressiveness of the figures' faces, glances, and gestures. Rosenberg describes the passage around Christ's left hand held by St. John as intricate yet clear, while the comparable passage in the copy, which lacks fine gradations of line and tone, appears empty. Similar contrasts of degrees of richness are found in other passages of the original and the copy that bear on the works' greater or lesser articulateness, subtlety, and expressiveness.

Moving to the twentieth century, of two abstract prints, one by Picasso and another by Albert Gleizes, Rosenberg writes that the Picasso has an animated and coherent pattern in which controlled repetition and variety and contrast of colors and shapes "are combined with a high degree of integration and gradation and a well-balanced distribution of attraction" around a central form. "Light and dark, cool and warm colors, striped and punctuated patterns are not merely poured out and loosely combined, but are selected with high economy and expressively related within a tightly organized design." Though the Picasso may appear simple, it achieves intensity of expression and a telling character by virtue of its complex formal relationships. The slightest change in the composition would disturb its overall balance. In contrast, a similar work by Gleizes is a mere aggregate of colors and shapes, "a jumble of details that lack any strong organization or clear articulation of accents." Its quality of monotony is a function of dull repetitions of vertical movements and the closeness of colors. Nowhere apparent are the "striking yet graded contrasts of the Picasso, its clear-cut quality, the mere expressive variety of its shape, and its vigorous economy." These are but two comparisons among many made by Rosenberg which merit reading for their instructive value.

In an essay on quality in painting, Sherman E. Lee takes up where Rosenberg leaves off by extending the search for excellence in Western and non-Western painting. Working with a notion of excellence as comparison within kind, Lee too states

that the quality of formal organization, that is, the fusion of medium, design, subject, and meaning, is decisive in assessing degrees of artistic excellence. Comparing the quality of two traditional Chinese scroll paintings, Lee speaks of the superior quality of a Ma Yuan landscape in terms of its suppleness, liveliness, variety, and individualism whereas the lesser of the two scroll paintings appears mechanical and characterless.

Kenneth Clark's essay *What Is a Masterpiece?* contains an even more insightful discussion of quality in painting. Clark discusses several works which range from Giotto's *Lamentation over the Dead Christ*, Raphael's *School of Athens*, and Rubens's *Descent from the Cross* to Rembrandt's *Night Watch*, Courbet's *Funeral at Ornans*, and Picasso's *Guernica*. What do such works possess in common? How do they continue to claim our attention? Each masterpiece, says Clark, answers these questions in its own way, but certain features of excellence recur in his remarks.

Masterpieces of art are great exemplars of artistic value because they fill the imagination and express deep and complex emotions. They make no concessions to mere visual appeal and reveal the supremacy of the artist in their masterly form and finality of design. Most importantly, masterpieces disclose the ways in which artists have reworked traditional ideas and forms in order to make them expressive both of themselves and of the times in which they lived while retaining a significant link with the past.

Masterpieces fill the imagination in part because of their complexity and expressive intensity, the latter being further magnified when there is an important story to tell. If the story is a tragic one, then the work is likely to move us even more deeply. This is not to deny the existence of numerous masterpieces that celebrate the life of the senses and other less tragic aspects of human life. Clark himself has written exuberantly about the nude in the history of art. But excellence of the highest order is not likely to be achieved without a profound commitment to human values and an effort to understand the human condition.

In terms similar to those used by Rosenberg and Lee, Clark finds the excellence of masterpieces in their inspired virtuosity, supreme compositional power, intensity of feeling, masterful design, uncompromising artistic integrity (even down to the

smallest details), imaginative power, originality of vision, and, once more, a profound sense of human values. Once again, of all the major characteristics of masterpieces, Clark speaks of two as especially noteworthy: "a confluence of memories and emotions forming a single idea, and a power of recreating traditional forms so that they become expressive of the artist's own epoch and yet keep a relationship with the past."

Are there masterpieces of modern art? Or are we too close to our own time to have made any definitive judgments? It depends in part on what the terms "modern," "modern art," and "avant-garde" mean and the period during which one thinks modern movements occurred. For example, there is now the notion of "postmodernism" to contend with, which suggests that modernism has evolved into something else. One treads on such terrain with less assurance, however convinced that high degrees of excellence have been achieved in the art of the last 150 years. Certainly the case of "the modern masters"—say, from Manet through Picasso—is less problematic. We recall Cézanne's successful effort to find a vision genuinely his own that combined the palette of the Impressionists and the seventeenth-century French painter Poussin's sense of form. And while, as Rosenberg pointed out and Clark emphasized, traditional masterpieces typically tell great stories, Meyer Schapiro has persuaded us that Cézanne managed to invest still lifes and landscapes with the same high seriousness that the old masters accorded classical and biblical themes. In short, in the case of Cézanne most of the major characteristics of masterpieces are present. And the same can be said of Picasso. Not only the *Guernica* but also his interpretations of Velázquez and Delacroix reveal Picasso's ability to rework tradition in a contemporary idiom.

But surely, it will be said, the modern masters are not the whole story of modernism. Surely there are modern works that turn their back on traditional criteria of artistic excellence, that repudiate qualities of formal organization, articulateness, sublimity of expression, and, at a certain point, artifactuality itself. Surely we are on radically different ground or watching a different plot unfold when we witness artists resorting to blandness and boredom, on the one hand, and mere shock and destruction, on the other, all ploys of the recent avant-garde. At

this point we are in need of reliable guides. Let us first consider an essay on quality in the avant-garde by Harold Rosenberg, one of the major art critics of the mid-twentieth century.

According to Rosenberg, the avant-garde—and he is now talking about Impressionism, Post-Impressionism, and Cubism, as well as Surrealism, Dada, Pop, Op, and their variants—had above all the quality of *freshness*, which it achieved in numerous ways. Repudiating noble and historic subject matter and the kinds of compositions that contained it, Impressionism, to take but one example, sought through *plein-air* painting to capture the transitory qualities of light and atmosphere of scenes from ordinary life. In the case of Surrealism, Dada, and Futurism, however, the avant-garde searched practically everywhere for ideas and suggestions—the past, the present, psychoanalysis, radical politics, even the mysteries of science. Committed to brandishing the new, it startled and shocked with dark and somber foreshadowings of things to come and was often savage, ruthless, and violent. Given to acts of vandalism against established artistic conventions and revered customs, it especially delighted in offending the middle class. The vandalism was also perpetuated by subsequent avant-gardes; for example, if traditional picture making valued permanence, spatial illusion, and artifactuality, latter-day vanguardists made self-destructing objects and works that banished illusion and the conventions on which it depends. Art could now be merely an idea or intention in the artist's mind, however boring or absurd. Indeed, a "work" could consist of nothing more than an artist's notarized statement that withdrew all aesthetic quality from one of his own creations. Desired offensiveness could further be achieved by presenting people in the flesh, literally, and in happenings and live theater nakedness and bizarre eroticism became common fare. Even self-mutilation came to be understood as an artistic act. In other words, inverted order or no order at all became the order of the day, reductionism and radicalism key gambits, and the banal something of a banner.

A program of constant change and shock could not, however, sustain itself. Aesthetic freshening and renewal soon succumbed to the imperatives of fashion. This meant that a work's acceptance often depended more on aggressive marketing techniques than on any inherent aesthetic value it might have. Vanguardism

died when it became institutionalized in the museums and history books where it ceased to be a dynamic force for change and became instead just like that against which it had rebelled— an object for contemplation and study.

Once more, because avant-garde art presents us with a perplexing and anxiety-inducing landscape in which it is easy to lose one's way, the offices of good guides are needed. Rosenberg helps us to appreciate the freshness of early avant-garde art. He describes the extent to which it served modern art well (until, that is, it became fashionabilized), with its appropriations and transformations of the past and present. But he does not distinguish between two rather separate tendencies of modernism which Hilton Kramer describes in his *The Age of the Avant-Garde*.

One tendency of the avant-garde, says Kramer, was its appreciation of past artistic accomplishment, evidence of which can be found in the obligation several major artists felt, however unconsciously, to work through artistic traditions in order to express new aesthetic values. Picasso and Matisse reveal the continuity of culture and renew its deepest impulses, an observation we have already had occasion to make about creators of masterpieces in general. Marcel Duchamp represents the second tendency of the avant-garde with his radical gestures toward the conventional idea of art, gestures that culminated in acts of anti-art. Kramer thinks that this tendency, which stresses constant change and revolt and is often politically motivated, has received inordinate attention. As we gain distance from the heyday of the avant-garde and as its shock waves subside, Kramer thinks it is becoming clear that it is the more traditional (he calls it progressive) and not the revolutionary strand that constitutes the major plot of modernism. Vanguard revolutionary art, however, not only repudiated tradition. Because of its flashiness and determination to steal the show, it also converted a large following to its program and in the process trampled countless artistic treasures underfoot. Thus, according to Kramer, the central task of criticism today is that "of digging out a lost civilization from the debris that has swamped and buried it."

If Kramer is correct, if the more traditional tendency of modernism represents its best and most valuable contribution, then there seems little doubt that, with appropriate qualifica-

tions, traditional criteria of artistic excellence are still relevant and there is no need to make significant exceptions in our observations about the nature of excellence in art.

But what about the new art form of film? Must we not modify our notions of artistic excellence in assessing the quality of this twentieth-century medium? Perhaps. A number of writers stress that even in films that aspire to high seriousness and artistic quality the conditions of filmmaking—notably its economic imperatives (films are expensive to make) and the nature of film culture itself (in which so much kitsch or pseudo-art coexists, perhaps on the same double bill, with mature examples)—limit the degree of excellence attainable. This condition prompts some writers to speak of film's capacity only for fine failures. There are no doubt films that transcend the status of a fine failure, but we know what is meant. For example, in an essay on quality in film, Stanley Kauffmann cautions that the term "classic" must be considerably hedged in when we talk about films, and not only because time has not rendered its usually reliable judgment, but because of the inherent dynamics, cultural context, and economics of movie making. Despite these reservations, film is in principle no less capable of attaining excellence than any other art form, nor should films be subjected to anything but the highest standards. Such standards make the notion of a fine failure intelligible.

Not surprisingly, the criteria of excellence Kauffmann discusses are similar to those used in judging more traditional forms of art: films are good or excellent because of their inventiveness, imaginative energy, dramatic content, technical competence, and, more germane to the medium, dialogue and characterization, capacity to transform literary into cinematic values, psychological complexity, and spiritual power. Since the medium of film is largely photographed reality and thus inherently suited to dramatizing and symbolizing human experience, the ultimate criterion of judgment for Kauffmann is moral. Kauffmann seems to expect no less from film than what Lionel Trilling expected from literature: a knowledge of the self and of the right relations of the self to others and to culture. "To the degree," writes Kauffmann, "that a film clarifies or exposes a viewer to himself, in experience of the world or of fantasy, in options of action or of privacy, to the degree that he can thus

accept a film as worthy of himself or better than himself, to that degree a film is necessary to him; and it is that necessity that sets its value."

If Kauffmann underlines moral criteria, it is not because he thinks aesthetic criteria are irrelevant, for *how* a work invites us to think of ourselves is extremely important. Any number of films convey the message that the use of violence implies concomitant responsibilities, but only a truly fine film, as Martin Dworkin has pointed out, will fix this fact vividly in our imaginations. And it is the aesthetic properties of films that do that for us. Kauffmann further emphasizes the importance of a quality of good films that we came upon in our discussion of masterpieces—their reworking of tradition in a contemporary idiom. In terms recalling Clark's, Kauffmann writes of Antonioni's *L'Avventura* that his immense talent has been used "to make the film respond formally and morally to our changing times, yet without forsaking what is still viable in the tradition." The same can be said of other outstanding films. Owing to film's relative youthfulness as an art form, it is also typical that critics may give attention not only to a film's moral cogency but also to the ways it reveals new potentialities of the art, when, for example, editing and color or new special effects are used in novel and dramatically successful ways. In "Basic Film Aesthetics," Francis Sparshott says that a film's failure to exploit imaginatively the potentialities of the medium is in fact a good reason for lowering one's estimate of it. But there is no critical dispensation for film. If it is to achieve excellence, says Kauffmann, it cannot be immune from what he calls summit judgments.

The discussion of this section should leave little doubt about the meaning of excellence in art. Each writer—Jakob Rosenberg, Sherman E. Lee, Kenneth Clark, Harold Rosenberg, Hilton Kramer, Stanley Kauffman—contributes to our understanding of artistic excellence, which, once more, is understood in this essay as the capacity of art at its best to afford worthwhile experience and the qualities whence such a capacity derives. Indeed, apart from viewing works of art themselves, there is no better way to renew one's faith in the powers and delights of art

than to read what our most perceptive writers have to say about art's special qualities. What we have learned, moreover, is what Beardsley discovered in his effort to clarify the nature of the critical evaluation of art: judgments of art tend to feature cognitive, moral, and aesthetic reasons. Jakob Rosenberg's criteria are mainly aesthetic, Clark's aesthetic and cognitive, and Kauffmann's moral. This is to say that in judging the excellence of art we appeal to both aesthetic and nonaesthetic standards.

Further insight into the nature of the criteria of artistic merit is provided by Osborne, who writes that we praise a work of art mainly for three reasons: for strictly artistic reasons, or for a kind of artistic virtuosity evident in the completed product; for its capacity to provide aesthetic satisfaction in a responsive beholder, which is to say for a work's capacity to sustain perception in a distinctive mode of attention; and for its stature, or for the ways in which a work performs well any number of subsidiary functions, not least of which is its ability to suggest imaginative models for thinking about the world and human nature. Nelson Goodman also believes that works of art function most effectively "when by stimulating inquisitive looking, sharpening perception, raising visual intelligence, widening perspectives, bringing out new connections and contrasts, and marking off neglected significant kinds, they participate in the organization and reorganization of experience, and thus in the making and remaking of our worlds." On this Deweyan note, that is on Goodman's stress on art's contribution to the organization and reorganization of experience, we return full circle to the notion that excellence in art consists of its capacity to occasion worthwhile experience by intensifying and enlarging the scope of human awareness.

To pause for a moment. It might be said that in talking so much about the excellence and qualities of works of art, we have given natural phenomena undeservedly short shrift. Should not efforts to develop an appreciation of nature's beauties also be part of any program of art education? Undeniably, the term excellence tends to imply human agency, so that it would seem to strain ordinary usage to speak of the excellences of nature. Yet this would be unconvincing to many artists for whom nature has indeed been a source of inspiration. One need only go through Kenneth Clark's *Landscape into Art* to realize this.

And so nature is not excluded after all; it is there in the inter-
ests, perceptions, and works of artists themselves, in Breughel,
Rubens, Poussin, Constable, Courbet, Monet, Turner, Cézanne,
van Gogh, and others. When discussing the works of such artists,
teachers need only move back and forth between nature and art
and make the appropriate distinctions.

What ultimately gets emphasized in developing an understand-
ing and appreciation of art is, of course, largely conditioned
by the cultural climate of a period. This climate usually consists
of a mixture of traditional and contemporary thinking about
art. There is nothing inevitable, however, about either the ideas
themselves or the direction they take, and just because certain
ideas are on many people's minds does not mean they are nec-
essarily the best ideas.

To a large extent, interest in art today is ideological in nature
and expresses itself in theories that tend to stress the political,
economic, or social aspects of art at the expense of art's aes-
thetic values. Yet Virgil C. Aldrich has written "that the great-
est art is formally expressive at once of materials on the one
hand and of subject matter on the other, doing justice to both
in a reciprocal transfiguration, each inspiring the other in the
content of the composition." This, it may be said, is the fun-
damentally aesthetic business and achievement of art. The more
the subtle and precarious balance among the relations of medi-
um, form, and content is upset—e.g., by an inordinate intrusion
of ideological concerns—the less likelihood the work has of
achieving its full potential for expressive statement and aes-
thetic response. The writers discussed in this chapter assume the
pertinence of Aldrich's criteria for greatness in art. Today, how-
ever, there is often less interest in the aesthetic plentitude of
works of art than in their ideological meanings and political
uses. The result is a reductionism of values that is inimical to art
and detrimental to art education. It is detrimental because it
commits the fallacy of misplaced emphasis. Instead of taking
the measure of a work of art in terms of its artistic virtuosity,
capacity to afford aesthetic experience, and stature, which *may*
involve taking into account a work's political or ideological
import as part of an *overall* assessment, those who commit the
fallacy of misplaced emphasis stress political significance at the
expense of art's inherent values. They thereby slight those

qualities that constitute the capacity of a work to afford high levels of aesthetic experience. It can in effect be said that a politics of art reduces art to an ideological message center where one gets news about certain kinds of social and power relations in a society. The consequence, as Hilton Kramer has recently pointed out, is that aesthetic intelligence and experience are believed to be largely beside the point. Rather, the intention is "to discredit the idea of *aesthetic* achievement in art and replace it with scenarios claiming to represent an authentic *social* history of art." In truth, as Beardsley has remarked, much of what we are getting today is not art or aesthetic criticism proper so much as cultural criticism passing for art criticism. Cultural criticism, moreover, usually means varieties of Marxist commentary that often goes by the name of critical theory. But in assessing the excellence of art, as the writers discussed in this chapter clearly indicate, extra-aesthetic political or ideological values are never enough. Qualities of complexity, formal organization, and dramatic intensity—qualities that, once again, constitute the aesthetic achievement of art—are crucial; they make art the special thing it is. Saying this does not denigrate the extra-aesthetic or non-aesthetic values of art; it merely keeps them in their proper place. Since an excellent work of art embodies different kinds of value that, ideally, exist in dynamic equipoise, the critical task is to keep the complete manifold of values in view. What must be avoided in art education is the acceptance of theories more concerned to further a political ideology than to understand and appreciate art in its true complexity. It is therefore important that an excellence curriculum for art education reaffirm the intrinsic and inherent values of art and put political and ideological interests in proper perspective.

There is another issue—that of knowledge and art—that this essay introduces but does not resolve, in part because it is not resolvable to everyone's satisfaction. Sparshott has said that the only thing that keeps systematic thinking about art alive is either finding confirmation for or abandoning the idea that art is a form of knowledge. Is art primarily cognitive or aesthetic? Or both cognitive and aesthetic, and perhaps moral as well? When confronted with the numerous functions works of art may perform, some writers tend to acknowledge the plural-

ism and then proceed as if no serious attempts have been made to narrow the possibilities. Or they make the standard response that art is cognitive, moral, and aesthetic and leave it at that. But it can make a difference whether one thinks works of art exist primarily to be understood and to provide knowledge or whether their function is to lend a certain character or quality to experience. The fact, moreover, that some of our most respected writers on this matter hold conflicting views should not be lightly dismissed.

If we take an essentially aesthetic view of the function of art, we can think of art in the manner of John Dewey. In his *Art as Experience*, Dewey describes a dramatic organization of elements that makes any ordinary experience a truly noteworthy experience, *an* experience. Such experience is distinctive mainly for its inner dynamics and consummatory value, that is to say, for its *aesthetic* quality. Any cognitive residue yielded by such an experience is less important than the way the experience unfolds and feels. Experiences having aesthetic character, Dewey says, really go nowhere; they do not yield conclusions that can be used in further inquiry the purpose of which is to produce still more understanding. This is not to say that knowledge, ideas, and judgments do not figure in artistic or aesthetic experience; it is that the person having *an* experience feels that its elements and components cohere unusually well. In this respect, Dewey's idea of art is essentially noncognitive, and those who appeal to his writings to support a cognitive function of art misrepresent his central emphasis.

If we think of the function of art as preeminently cognitive, we might do so after the manner of Nelson Goodman. In his *Languages of Art* and elsewhere, Goodman speaks of art's capacity to transform and reorganize our conceptions of the world, a view that stems from his theory of symbolic systems in which the characters of a given symbolic system function more or less efficaciously. Goodman has little to say about the quality of experience that art affords other than to indicate the active character of our response to art during which the feelings are engaged cognitively.

Osborne's remarks cited at the opening of this chapter seem to suggest that art accommodates both functions: works of art intensify experience and provide insights. But his main emphasis

is on the energizing of perception. And although Beardsley in his later writings paid greater attention than he had previously to the cognitive character of aesthetic experience, his view of art's function remains largely noncognitive; that is, works of art are more suited to provide high degrees of aesthetic gratifications than knowledge or understanding.

There are then two senses of the term "cognitive" featured in our thinking about art which, if kept separate, can avoid confusion. The first sense may be called a process sense; that is, cognition plays a role in our perception and experience of art inasmuch as such experience presupposes the deployment of relevant knowledge, skills, and judgments. This can also be called the conceptually mediated component of aesthetic experience. A second sense of cognition refers to the humanistic import or insight provided by an art object and implies its symbolic character and meaning.

Although the issues surrounding the relations of the aesthetic and the cognitive are far from being resolved, educators have valid reasons for emphasizing the former as well as the latter. At a time when political interests and extra-aesthetic considerations—not only in totalitarian countries but also in Western democracies—figure so prominently in discussions of art and art education, it is worth underlining the importance of an aesthetic justification for art and art education. As conceived by major theoreticians today, such a justification is neither narrow nor mere aestheticism. Even though aesthetic experiences tend to be self-contained, they nonetheless have potential for influencing other important values of life. To repeat, it is reasonable to assume that a cultivated disposition to regard art aesthetically can contribute not only to the development of aesthetic percipience but to percipience generally, not only to the stretching of aesthetic imagination, but of imagination generally, and not only to an appreciation of artistic complexity and possibility, but of variety, difficulty, complexity, and possibility generally, qualities which a society beset with intolerant, single-minded ideological impulses does well to cherish. But readers may decide for themselves whether their motives for attending an exhibition of Renoir paintings, a show of Henry Moore sculptures, or a festival of Hitchcock films are mainly cognitive, aesthetic, or moral. Do people seek out art

mainly for understanding and learning or for a fresh experience—or both? Do they believe their experience of the arts significantly influences other aspects of their lives?

By now, however, one thing should be quite apparent: the question of excellence in art cannot be decided without taking into account aesthetic theory. If one thinks that the principal use of art is to help moralize people, as Plato and Tolstoy did, then art will be judged largely in regard to its moral effects. If one thinks the principal function of art is cognitive, that is, to contribute to our understanding, as Goodman does, then judgments of art will center on the degree of a work's symbolic efficacy. Or, still further, if the foremost function of art (which is not to say its only function) is believed to be aesthetic, as both Osborne and Beardsley do, then art will be judged excellent to the extent that it has the capacity to induce a high level of aesthetic experience and sustain interest in the aesthetic mode. If one is basically a pluralist open to all the possible functions of art, then one will move among points of view and, after the recommendation of Morris Weitz, try to look at works of art in light of what each theory considers to be art's characteristic excellence or excellences. No one, however, who has a serious interest in art really believes that all viewpoints are equally cogent or educationally worthwhile.

This concludes the discussion of excellence in art, and in addition to explanations of quality in art the discussion has had the effect of qualifying Santayana's principal reason for studying the past; it was, he said, to avoid reliving its mistakes. But when we consider the study of artistic excellence, we see that this is only one possible reason. We do not return to masterpieces again and again in order to prevent ourselves from committing what Ortega y Gasset in a frame of mind similar to Santayana's called the ingenuous mistakes of history, but to honor those rare moments of human accomplishment when excellence manifested itself. In this respect, our attitude is one that celebrates and pays homage to the past.

3 Excellence in Art Education

> Just as it is dangerous to entrust the life of the nation and the world
> to citizens ignorant of good science and technology, so it is danger-
> ous to entrust it to men and women whose feelings and values are
> uncultivated and undisciplined. This is the overriding reason for the
> cultivation of the young in the aesthetic dimension of experience.
> For a good society there must be enlightened cherishing.
>
> *Harry S. Broudy*

The introduction indicated that we are going through a period
in which attention is centered on the more global aspects of
schools, on what is increasingly called "schooling." Countless
ethnographic studies of the cultures of schools and volumes
such as Goodlad's *A Place Called School*, Boyer's *High School*,
Sizer's *Horace's Compromise*, and Lightfoot's *The Good High
School* exemplify this trend. The study of schools rather than
the more discrete aspects of them stems mainly from impatience
with varieties of reductionism in studies of education. There is
impatience not only with mechanistic views of human behavior
and learning manifested in behavioral learning theory but also
with assessments of schooling's effectiveness along only one
rather than several of its dimensions.

Dissatisfaction with the shortcomings of behaviorism has
spawned a cognitive revolution in learning theory that is yield-
ing promising speculation about the ways in which the human
mind comprehends and learns things. Unhappiness with exces-
sive reliance on quantitative measures of educational achieve-
ment has generated an energetic literature of educational
evaluation that is currently deriving ideas and models from such
different fields as anthropology, investigative reporting, and art
criticism. Whether this literature will revolutionize thinking
about educational evaluation in the way cognitive learning
theory has altered thinking about human learning is uncertain.

Its fundamental assumption, however, must be acknowledged: there is more to educational evaluation than the so-called numbers game.

The designers of excellence curriculums for art education would do well to acquaint themselves with both the cognitive revolution in learning theory and what may be called milieu studies of schools. This essay reflects an awareness of both but assigns more importance to the former. The reason is that the field of art education stands in greater need of justification as an academic subject than it does of milieu studies. Such studies should be deferred until art has become a staple of a required curriculum, that is, until there is an established milieu to study. At this time such inquiries only deflect attention from first things. The emphasis in this chapter then is on the kind of curriculum in art education that is congruent with the general goal of developing a disposition to appreciate excellence in art. This emphasis underlines the formal academic function of schools and the development of requisite cognitive skills. But, as chapter 2 indicated, the justification of art education as an academic subject does not mean that imagination and feeling receive short shrift.

It is felicitous that a recent publication of the American Educational Studies Association not only stresses the multiple functions of schools and cautions against reductionist thinking, but also emphasizes the development of *intellectual power* as the primary purpose of schooling. In *Pride and Promise: Schools of Excellence for All the People*, we read:

> Both individual interests and the nation's most fundamental commitments recommend that the school's primary purpose be the development of intellectual power. This transcending goal must infuse the culture of the school. It must be translated into curricula which acknowledge that student performance below certain levels of literacy means lifelong disadvantage, that skill acquisition below certain levels means limited opportunities and mortgaged futures. It must be reflected in the way schools are organized and the way in which *all* people therein are treated. It must also suffuse the content and the activities through which schools seek to carry out several quite different functions parents want them to fulfill: [i.e., academic, social/civic, personal, and vocational]

Concern for the development of intellectual power should infuse the whole culture of the school, including the content

and activities by means of which the schools achieve their non-academic social, personal, and vocational objectives. If to some the idea that art education too should stress intellectual power sounds dissonant, it is because the field has harbored serious misconceptions about the nature of art and learning. A proper view of the nature of human understanding, however, will dispel fears that intellectual rigor and aesthetic considerations are incompatible. To quote the authors of *Pride and Promise* once again:

> There are different kinds of knowledge and there are different objects of knowledge. We want youngsters to become acquainted with the array. Thus it makes sense to require that each become familiar with particular forms of literature; the sciences; mathematics; the social sciences or social studies; the fine and performing arts. It seems reasonable to ask that each youngster's high school career include extensive attention to these five areas. Such a requirement, however, need not specify either an organization for the content or a particular method of instruction.

By the latter the authors mean that curriculum designers should state requirements only in terms of basic concepts and skills. Given the nature of a particular school—its teaching staff, resources, and student population—content can be organized in different ways to teach basic concepts and skills, and the curriculum can be planned in light of student needs, interests, and maturity with no sacrifice in rigor.

In the case of an excellence curriculum for art education, however, it will not always be possible to separate the teaching of basic concepts and skills from specific content nor to be indifferent to the nature of teaching method, for to a large extent an excellence curriculum implies a certain organization of knowledge and particular teaching methods. Certainly it is insufficient merely to say students should become acquainted with forms of literature and the fine and performing arts, for that only raises the question of what "acquaintance" and "forms" mean and begs the issue of what kinds of literature and fine art should be studied. For an excellence curriculum these cannot be arbitrary matters; in such a curriculum students will learn to perceive and talk not about any kind of art but about excellent art, that is, classics, masterpieces, exemplars, and art that is good within its kind.

Not only that. Once it is recalled that appreciating a master-piece presupposes familiarity with the traditional ideas and forms artists have reworked, the matter of sequential learning cannot be ignored. One cannot appreciate excellence in art without a rich apperceptive mass to which knowledge of art history and much else have contributed. Or, to borrow a term that enjoys some currency today, it may be said that one per-ceives works of art *with* a sense of an artworld. The fact that the appreciation of a masterpiece presupposes knowledge of earlier works and styles implies that familiarity with the his-tory of art is important in building an artworld sense. Put in different terms, a sense of an artworld is simply an interpretive framework for experiencing art. All this suggests that an excel-lence curriculum calls for specific concepts, skills, and content and even courses or units of study. Introductory and survey courses should precede exemplar appreciation with critical study of issues to follow.

An excellence curriculum further necessitates certain kinds of teaching. As one moves from courses designed to give students a sense of art and its history to others where they obtain a feel for artistic process to still others intended to refine critical thinking about the arts, a full repertoire of teaching methods comes into play: not only didactic (imparting of information) and heuristic (problem-solving) but also dialogic (Socratic) methods and others.

An Excellence Curriculum for Art Education

We may best understand what is involved in developing a dispo-sition to appreciate excellence in art through recommendations for an excellence curriculum. A discussion of curriculum must address not only the *what* of curriculum (its concepts, skills, and content) but also *how* and *when* things get taught (the problem of teaching method and sequence of learning). To the questions of what, how, and when, the basic trinity of concerns of curriculum theory, may be added the question of *how well* things are done (the problem of evaluation).

An excellence curriculum for art education should first of all be part of a program of education that is common as well as general. Certain areas of study, basic concepts, skills, and con-

tent germane to cultivating human thought and feeling should be required of all students (grades 7-12). This is what it means to call it common. Such a curriculum should also be designed for the ordinary citizen as a nonspecialist. This is what it means to call it general.

An excellence curriculum begins to take shape when art is conceived as a subject much as other subjects are, that is, as an area of study with its own objectives, content, and methods. While teachers of any subject are free to use the arts or anything else to attain their objectives, the development of an appreciation of excellence in art can be done justice only by devoting specific time to it. Art, one of the supreme achievements of humankind whose powers for affecting thought and action have been remarked since antiquity and whose potency is especially attested by totalitarian societies in their determination to control it, demands its own curriculum time and space. This point may seem obvious but for the fact that there are influential points of view to the contrary which adversely affect our thinking about policymaking for art education.

The idea that art consists of humanly fashioned artifacts that at their best have the capacity to induce high levels of worthwhile experience suggests certain pedagogical considerations but still leaves much unsaid. In particular, it does not address the nature of the various components of appreciative capacity. Nor does it settle the question of how much knowledge about art is necessary in order to appreciate it—how much art history, art criticism, art production, aesthetic theory? Then there is the matter of apportioning time to the study of the various contexts of art instruction, including the study of puzzling topics and issues. Regarding the latter, Arnold Hauser has remarked that art is at once form and content, an affirmation and a deception, a form of play and revelation, purposeful and purposeless, personal and superpersonal. How can something be so many different things and perform such contradictory functions? A famous maxim asserts that there is no disputing of tastes. But how can that be when tastes are continually being disputed and, it would seem, for good reasons? And perhaps the most perplexing problem of all for the curriculum designer is how one fashions an art requirement from so many paradoxes and different perspectives. Where does one begin?

What must teachers know? What must those who prepare teachers know?

The task is to find a place to begin, and to stop, for obviously not all possible viewpoints about art and art education are equally cogent. In an attempt to narrow the options, one consideration is extremely important to keep in mind. In discussions of art and art education can one can detect a fundamental rapport with the subject? Are writers mainly interested in art and art education or are aesthetic interests subsidiary to political, economic, social, and personal values? The authors discussed in chapter 2 reveal the kind of understanding and love of art that attracts one to their writings. As already mentioned, however, writers today tend to superimpose theoretical frameworks on discussions of art which serve not so much to reveal art's inherent values as to accord a place for art in a social theory, irrespective of whether the fit is a comfortable one. The tendency to see art in essentially class terms in order to make it consistent with Marxist principles is a case in point. Once more, theorists of art education should be wary of ideas inimical to art and of writers whose interests really lie elsewhere.

The first obligation of curriculum design is to address the question of *what* shall be taught, which breaks down into two tasks: first, a description of the dispositions to be developed in art education, and, second, an account of the concepts, skills, and content relevant to fashioning them.

Doubtless art education strives to build dispositions that schools attempt to foster through most of their activities; that is, dispositions to think critically, to behave compassionately toward others, and to act on behalf of the public interest. In addition to these, there are those dispositions specifically pertinent to understanding and appreciating particular subjects; in the case of art these are the dispositions to regard works of art attentively, to entertain the relevance of the cultural heritage, and to develop a tolerance for what is often ambiguously and indirectly expressed. What is important to know is that the most fundamental objective of art education is the development of relevant dispositions.

A basic disposition to be developed through schooling is a disposition to use knowledge and learning in appropriate ways,

in aesthetic situations no less than in others. Perhaps the most persuasive statement of the uses of learning in this sense is found in the curriculum theory presented in *Democracy and Excellence in American Secondary Education* by Harry S. Broudy, B. Othanel Smith, and Joe R. Burnett. Published in 1964 and still available in a reprint edition, this volume, because of its theme and contents, continues to be relevant.

The theory of learning Broudy, Smith, and Burnett commend to curriculum designers asks what is involved in a generalist's, or nonspecialist's, understanding of the basic situations of daily life—for example, reading a newspaper, following a logical argument, contemplating a work of art, and making mathematical computations. What kinds of knowledge, learning, or skill must be replicated, associated, and applied to a situation in order for persons to interpret and understand it intelligently? Scholars working at the most advanced edges of their disciplines interpret situations by replicating, associating, and applying knowledge for the purpose of solving problems of the very first order. The ordinary citizen as nonspecialist also replicates, associates, and applies knowledge in an attempt to interpret and understand phenomena, but not with a view to solving complex problems after the manner of the specialist or frontier scholar. The nonspecialist simply seeks comprehension commensurate with the frames of understanding available. The general disposition an excellence curriculum in art education attempts to develop then is *a disposition to use knowledge and learning in appropriate ways to appreciate excellence in art, the purpose of this being to occasion in a receptive viewer the kind of worthwhile experience that art at its best is capable of providing.*

The notion of dispositions and their development prompts a further question about the organization of knowledge and skills in art education. Does art education have a structure of knowledge? The first thing to realize is that the term "structure of knowledge" is relatively meaningless used out of context. Usually it implies concepts that exist in a relation of logical subsumption, that is, one concept logically subsumes another such that in learning the structure of a subject certain concepts must not only be learned in relationship but in a certain order, usually in the order presented in textbooks. This is characteristic of such highly systematic fields as physics and mathematics.

"Structure," however, can refer merely to the ways in which important ideas are organized for purposes of teaching and learning. The problem then is not that of discovering the structure of art education, as if that were lying about waiting to be found, but of deciding what for one's purposes the term structure is to mean in art education.

It is useful to approach the question of the structure of art education by recalling the various contexts that come to mind when we think about art, those contexts that make up what Alexander Sesonske calls the aesthetic complex. Modifying somewhat Sesonske's remarks, the aesthetic complex may be said to consist of the context of artistic creation, which involves the making of art; the context of art history, which concerns the chronology, interpretation, and explanation of works of art; the context of aesthetic appreciation, which features acts of perceptive response to art; the context of critical judgment, which goes beyond acts of appreciation and emphasizes assessments of value or merit; and the context of critical analysis, which examines complex issues and puzzles in art.

Consider, for instance, some of the concepts brought to bear when we either contemplate, study, admire, criticize, or discuss an outstanding work of art. We may take as an example *The Rape of the Sabine Women* by the seventeenth-century French painter Nicolas Poussin, of which Paul Ziff says that when we approach it we

> may attend to its sensuous features, to its "look and feel." Thus we attend to the play of light and color, to dissonances, contrasts, and harmonies of hues, values, and intensities. We notice patterns and pigmentation, textures, decorations, and embellishments. We may also attend to the structure, design, composition, and organization of the work. Thus we look for unity, and we also look for variety, for balance and movement. We attend to the formal interrelations and cross connections in the work, to its underlying structure. We are concerned with both two-dimensional and three-dimensional movements, the balance and opposition, thrust and recoil, of spaces and volumes. We attend to the sequences, overlaps, and rhythms of line, form, and color. We may also attend to the expressive, significant, and symbolic aspects of the work. Thus we attend to the subject matter, to the scene depicted, and to the interrelations between the formal structure and the scene portrayed. We attend to the emotional character of the presented forms, and so forth.

This is quite a manifold of elements, relations, qualities, and meanings. But then this is why Clark said that works of art can fill the imagination and why Osborne believes it may take years or even half a lifetime really to see and appreciate a great work. It follows that we cannot lightly scan, say, Giotto's fresco paintings in the Arena Chapel at Padua, the *Ghent Altarpiece* by Hubert and Jan van Eyck, or Cézanne's *Card Players* if we wish to experience everything they present. The casual museum stroller who spends on the average five seconds in front of a work has but the slightest inkling of art's plenitude or of its capacity to enlarge awareness.

What does Ziff's account of contemplating a work of art tell us about the kinds of concepts and skills that should be acquired if we are to reap the benefits of aesthetic perception? It suggests quite a few; for example, concepts pertaining to the sensory, formal, technical, expressive, semantic, and symbolic aspects of art, and all the concepts that these concepts subsume. Such concepts, it will be noted, all belong to the side of the aesthetic complex where the art object itself is the most prominent feature. As one moves to the side of the percipient of art, concepts pertaining to the structure of aesthetic experience, which we have already had occasion to mention in chapter 2, come into play. In that part of the aesthetic complex involving artistic creation, practical principles of design and composition are featured. Other clusters of concepts belong to the contexts of art history and art criticism, but there is no need to list all of them here.

What do these brief remarks tell us about the structure of knowledge in art education? They suggest that it is important to discover the key organizing ideas of relevant contexts of instruction, for example, the concepts and skills involved in creating, confronting, and criticizing art. The structure of knowledge in an excellence curriculum, moreover, is not the structure of any particular discipline. It consists rather of a selection of concepts and skills relevant to cultivating a disposition to use knowledge in appropriate ways in order to appreciate excellence in art. An excellence curriculum, that is, is neither creative art, art history, art criticism, cultural criticism, the sociology of art, nor any other discipline, but an area of

study organized to achieve certain objectives for which knowledge from a variety of sources is relevant. The nature and difficulty of the knowledge pertinent to an appreciation of excellence determine the kinds of courses which make up an excellence curriculum. Accordingly, students will encounter concepts and contexts first in introductory courses, next in survey courses, then in exemplar studies (i.e., the study of outstanding works of art from stylistic periods), and finally in seminars.

A second major curriculum problem concerns the question of *how* to teach a subject. This means that the characterization of an excellence curriculum and an explanation of its enabling organization of knowledge must be supplemented by a few remarks about the nature and role of teaching method. Leads will be taken from conventional wisdom, the nature of an excellence curriculum, and the current literature on excellence in education.

In an excellence curriculum, the transmission of important information about the arts can be accomplished through conventional didactic teaching. When that occurs problem solving or discovery learning will be downplayed. Learning to find one's way around a portion of the artworld, say the medieval period, requires the services of a knowledgeable teacher and it is unrealistic and inordinately demanding to expect students to figure out for themselves how the style of high Gothic architecture, for example, gradually evolved from its origins in Early Christian art. Likewise with an appreciation of the richness and diversity of manuscript illumination during the same period.

If, however, the appreciation of excellence in art and the quality of experience art affords are goals, considerable time must be spent on individual works in order that one may savor their particular merits. As many have remarked, if quality in education means anything, it certainly means studying things in depth. In this connection, what is currently being called the teaching method of coaching is appropriate, in the instance at hand the coaching of appreciative skills. No doubt such coaching entails some didactic imparting of information, and exemplars of art surely present puzzles that provide opportunities for problem solving and critical thinking. But, again, the emphasis in exemplar study is on appreciation. Indeed, if teaching is in any

sense an art, this is what it consists of: knowing when to use particular methods to obtain certain results with given students.

In the course of learning to perceive the excellence of art, students will encounter a number of perplexing questions that can be clarified with what may be called dialogic (or Socratic) teaching methods. These are best used in seminars in which instructors and students analyze problems and issues for purposes of better understanding and where instructors encourage students to examine their own assumptions and beliefs about art. This type of teaching aims at the refinement of critical thinking within the study of the subject in question. Critical inquiry into art can even be extended into interdisciplinary contexts where students, drawing upon knowledge and skills acquired in art and other subjects, can examine what (because of their multidimensionality and complexity) are sometimes called "molar" problems: for example, problems that surface when art overlaps or becomes part of other areas of activity.

The above clearly indicates that an excellence curriculum demands a variety of teaching methods: didactic, heuristic, coaching, and dialogic, among others.

In addition to the problems of what and how to teach, there is the third basic curriculum question of *when* to present material. This is the problem of the sequence or order of learning. What precedes or follows what? What determines sequence? Where does one get ideas about it?

A conventional way to think about sequence is to examine the demands of the subject and of learning. For example, from an understanding of one of the important features of excellence in art—that exemplars of art reveal the reworking of traditional forms and ideas into contemporary forms of expression while maintaining a significant link with the past—it follows that to a considerable extent art must be studied historically. Otherwise it will be difficult to discern both continuity and change. Even when we get to that strand of modernism that self-consciously tries to reject tradition, it is difficult to comprehend what is happening without the backdrop of the past.

So far as the demands of learning are concerned, the secondary level presents fewer problems than the early years where the mysteries of intellectual development haunt the efforts of developmental psychologists. Adolescents, at least potentially,

have the capacity for abstract reasoning and critical thinking. Taking for granted a general familiarity with the characteristics of adolescence, teachers may straightforwardly teach their subject. To repeat, the demands of the subject and of learning suggest the general way in which to arrange the sequence of learning in art education and to put things together intelligently and sytematically over a period of six years. Those who would dismiss the problem of the order of learning by saying that art is notoriously nonsequential beg basic questions and shirk a major responsibility.

It would be foolish to try to systematize everything consistent with the demands of an excellence curriculum. Much must be left to the initiative and imagination of teachers and students. The theme of excellence, however, and the organization of knowledge relevant to developing a disposition to appreciate quality in art suggest what an excellence curriculum could be like.

Before sketching the outlines of such a curriculum, it is necessary to take account of the fact that the other arts—literature, music, theater, and dance—also have claims on curriculum time. This means that we must first address the question of an arts requirement at the secondary level in which we can locate the visual arts.

The response here is to suggest an arts requirement that consists of core and elective units. Although it would be ideal for each school to provide all of the needed instruction, that may not be possible and some nonconventional educational organizations, for example museums, may be called upon to assist. The greatest illusion of curriculum designers, however, is to think that everything someone wants can be included. Philanthropy has been defined as the sentiment that no one's feelings shall ever be hurt, but obviously choices must be made which not everyone will like. This essay proposes literature, music, and the visual arts as the arts to be taught. Owing to the nature of this essay, it naturally stresses the latter. To restrict the arts to three, however, is not as limiting as it might seem. The study of the visual arts could include the study of film, which is a mixed medium; the study of music could lead into dance; and the study of literature has affinities with both theater and film.

An arts requirement for an excellence curriculum might con-

sist of eleven units of study, distributed as follows.

One Unit: *Introduction to the Arts*

This unit introduces students to the idea of art and some of its exemplary instances in the visual arts, music, and literature. The emphasis is mainly on familiarization.

Two Units: *History of the Arts*

These units provide a chronological context within which later study of period styles can be located. It is important that students gain some awareness of how the arts developed simultaneously, or unevenly as the case might be, over time. Again, the units would stress the history of the visual arts, music, and literature.

Three Units: *Period Styles in Art History*

The purpose of the study of period styles is to gain an appreciation in depth of selected masterpieces. The emphasis would be less strictly historical than appreciative. In the visual arts, choices could be made from the usual period styles from antiquity to the present, although some balance between early and later periods is obviously desirable.

Two Units: *Studio Work*

In the visual arts, units of studio work in painting, sculpture, crafts, graphic art, photography, and filmmaking could alternate with units stressing the study of period styles.

Two Units: *Seminar on Special Topics*

Seminars could study a number of aesthetic issues and interdisciplinary problems in the arts.

One Unit: *Cultural Service*

> This unit could be satisfied with work in com-
> munity cultural organizations or in environmental
> groups.

What is important in an excellence curriculum is to develop
in students a disposition to appreciate excellence in art, and
this can be done only by studying carefully selected master-
pieces, classics, or exemplars in depth. What is recommended
here in the study of period styles is concentration on a small
number of works from each art, including, of course, master-
pieces of the visual arts. Perhaps students could elect some of
the period styles they wish to study; that is what is meant by
saying that the study of period styles is elective within the arts
sequence requirement. But all students would be required to
study in depth exemplars of visual art, music, and literature.
So far as studio work and performing activities are concerned,
students might elect work in either the visual arts, music, or
literature, or some combination of the three. Art educators can,
I think, rest assured that an adequate number of students would
elect studio work in the visual arts.

The arts requirement consists of units spread over six years
among introductory, intermediate, and advanced courses. These
courses emphasize objectives varying from simple familiariza-
tion and historical awareness to exemplar appreciation and criti-
cal inquiry. In such a requirement students would have ample
opportunity to elect some units that interest them, for example,
the units on period style or studio work; and even in the semi-
nar and cultural service requirements there could be opportu-
nities to express special bents.

The reasons for the introductory and survey units are perhaps
obvious, but it is worth noting that the excellence curriculum
presented herein also exemplifies a recent redefinition of the
humanities for the modern era. In *The Humanities Today*,
Albert William Levi redefines the traditional liberal arts as the
arts of continuity (history), the arts of communication (lan-
guages and literature), and the arts of criticism (philosophy). All
three "arts" are represented in the excellence curriculum. For
example, in requiring historical study of the arts we honor the
arts of continuity.

When students study the more specialized periods and styles of art, however, they arrive at the heart of an excellence curriculum; much more exclusively their attention now centers on masterpieces, exemplars, classics, touchstones, call them what you will. Such courses are less strictly historical in nature than appreciative, which is to say students practice the skills of perception and analysis with a view mainly to admiring the unique constellations of qualities and meanings that constitute the excellence of particular works of art. In doing this, students think and feel with the perspectives acquired in prerequisite courses while they continue to build a rich apperceptive mass that will serve them well in their future commerce with art. In concentrating on masterpieces of art and their distinctive ways of addressing us, we honor the arts of aesthetic communication, in this instance the languages of art.

Since the contemporary period has generated so many perplexing art forms and challenges our conventional thinking about art, indeed even casting doubt on the value of art itself, students should, after a rather substantial diet of artistic excellence, profit from an opportunity to explore and clarify a number of puzzling topics. In such courses students can be helped to fashion the rudiments of a personal philosophy of art. Mainly philosophical in character, the seminars would use dialogic methods of teaching and learning. They might well address themselves to such problems as the objective evaluation of art, the relations of art and morality, and even the thesis that art at its best has a capacity to induce a high level of worthwhile experience. Since such study would occur in seminar units devoted to critical thinking, the third part of Levi's redefinition of the liberal arts would be honored, that is, the arts of criticism.

Seminars could also deal with certain kinds of interdisciplinary problems. One thinks, for example, of Harold Rosenberg's essay that asks what happens when the arts enter the mass media system of communication. What are the gains and losses? Ronald Berman has examined the ways in which the definition of art is affected by public policies. Jane Jacobs wonders whether thinking of city planning after the manner of art is always productive of humane urban values. There is a tendency to become woolly-minded about interdisciplinary inquiry, and

it is not the intention here to identify it with the kind of random association of topics and subjects often found in descriptions of so-called interdisciplinary teaching in the early years. Serious interdisciplinary efforts presuppose well-informed minds that have something to apply to the problems in question. Consequently, it is recommended that studies of this kind come toward the end of the secondary years, not before. By that time the student will have acquired a reasonably rich apperceptive mass, a number of interpretive frameworks, and a curiosity that engenders commitment to inquiry.

While this essay is concerned mainly with the visual arts, an industrious and committed team of art, music, and literature teachers, perhaps even a department composed of these, might find it stimulating to accept the challenge to design a truly interdisciplinary arts requirement, one which tries to interrelate systematically courses or units of study in the three arts. This should be done, however, with awareness of some of the problems that surface when different kinds of specialists try to work together. For a number of reasons, interdisciplinary efforts invariably fail, one of them being the difficulty specialists experience in trying to communicate across disciplines. Another is the paucity of career incentives for commitment to interdisciplinary teaching. Some lip service notwithstanding, the professional arts education associations—the National Art Education Association, the Music Educators National Conference, and the National Council of Teachers of English, among others —do not really encourage it. Opportunities for career advancement, consulting, and textbook writing, moreover, exist mainly in the individual fields. Still, those trying to design a significant arts requirement for the secondary grades might well give some thought to ways in which the various offerings in the arts might be combined for the benefit of learning and not personal gain or professional career goals.

The notion of a cultural service requirement is taken from current recommendations in the excellence-in-education literature, for example, the Boyer report. Students, it is said, need to develop a greater sense of community and, just as importantly, of institutional realities. In some locations the fulfillment of a cultural service requirement will not be possible, in which case the time can be used for something else. But there are few

schools or communities where there are no opportunities to work in cultural organizations or environmental groups or where these could not be created.

A word of caution is in order about recourse to nonconventional ways of providing aesthetic instruction and cultural experiences. In the sixties and seventies, educational thinking yielded to varieties of alternative modes of education which tended to be valued higher than conventional modes. This preference was expressed most dramatically in calls for deschooling. The arts, especially the more "democratic" arts such as crafts, were often featured in what were known variously as free and open schools. Perceptive observers of alternative art education, however, pointed out that because such efforts tended to be politically rather than educationally motivated, they produced an "alternative tyranny" of their own that was often worse than the state of affairs they sought to supplant. Having said this, it should be noted that the idea of countercultural alternative education of the sixties and seventies is a far cry from Mary Ann Raywid's characterization of alternative education today as "pockets of excellence." She refers to magnet schools, schools within schools, and other ways of offsetting the increasing standardization of learning. Perhaps the energy of alternative educators and nonconventional learning efforts can be contained in desirable channels if it is expended in the fulfillment of an educationally defensible arts requirement and not in formenting social revolution.

A few words about creative activities. Their principal justification lies in their contribution to the building of the sense of art that we bring to appreciative acts. They are not absolutely necessary, but surely young people will be better able to admire the sensory qualities of artworks if they had been given opportunities to discover for themselves the inherent expressiveness of artistic materials, or to apprehend the formal qualities of design if they had been encouraged to weave their own webs of relations. They are also more likely to appreciate the achievement of style if they had at some time wrestled with the problems of making a personal statement. What we know about human development suggests that constructive activities are especially appropriate for young children, but they also have a role, albeit a subordinate one, to play at the secondary level. In

different terms, the making of objects contributes to the subsidiary elements that function in our interpretation and appreciation of works of art. Michael Polanyi has stressed that we know things with both ideas and feelings, and creative activities are one source of both. In more familiar Herbartian terminology, creative activities contribute to the composition of our apperceptive mass.

Because contemporary writers on schooling have made so much of the notion of "concomitant learning" and the "hidden curriculum," the existence of these ideas should at least be acknowledged, although the meanings of the terms have changed. Both notions started out being relatively neutral, implying merely that any curriculum is likely to do more than its designers intended and thus will have side effects; but a shift has occurred to more politically charged meanings that figure in ideological interpretations of the functions of schools.

A neutral example of one kind of concomitant learning is supplied by Cleanth Brooks, the literary critic. He says that in learning how to read a poem or play or story we are learning not only how to render poetic dicta intelligible but are also improving our understanding of grammar, logic, and rhetoric and acquiring knowledge of history, religion, and philosophy, that is, knowledge of the past and of systems of value and ideas. With appropriate changes, we may say the same for attempts to appreciate visual phenomena and artistic excellence in painting, sculpture, and architecture. As it is usually discussed today, however, the idea of a hidden curriculum implies the ways in which schooling reproduces the authority relations of the larger society.

Undoubtedly there are phenomena such as concomitant learnings and hidden curriculums. Yet it is difficult to avoid the conclusion that here has been too much preoccupation with these more occult aspects of schooling and learning. It is difficult enough to render tangible things intelligible. To be asked to render visible the invisible is expecting too much. The same goes for the attempt to divine the ambience of schools; it is becoming yet another educational fad.

A few words now about the *how well*, or the problems of evaluating an excellence curriculum. A range of methods are available for assessing the quality of an excellence curriculum,

but an intelligent observer can quickly discover if things are on track and being pursued in the proper spirit. What is not needed are elaborate literary descriptions, expressive portrayals, and detailed portraits of programs. The aestheticizing of educational evaluation has reached a pedantic stage, and there is a strong need to recenter assessment on a few essentials. The following questions are helpful to keep in mind.

Simply, forthrightly, and literally one might ask of an excellence curriculum in art education (1) whether it is a basic subject of a program of general education; (2) whether instructors are knowledgeable and qualified to teach art (which is not always the same thing as being certified); (3) whether there is congruence between stated aims and the actual curriculum; (4) whether teaching is adequate to the different objectives of historical awareness, aesthetic appreciation, and critical thinking; (5) whether there is some serious monitoring of the program; and, although hardly least important, (6) whether samples of student learning exemplify the building of the dispositions that are the desired results of the program. One can, of course, examine other items, for example, the quality of texts and materials, the commitment to in-service training, a sympathetic administration, and so forth. The point is that evaluation should be simple and helpful and not the literary art some curriculum theorists are trying to make it.

In scanning the eleven units of work recommended, readers will perhaps sense that they lend themselves to distribution over the conventional six grades at the secondary level, that is, grades seven through twelve. This is, of course, one possible way of distributing the work. But this suggests conventional half-year terms and fifty-minute periods, and it has become obvious to many observers of the schools that this conventional pattern should be modified in favor of one having more flexibility. What is important in the scheme proposed here is not a rigid timetable but the accomplishment of objectives. Based on their own estimate of resources and capabilities, schools can decide for themselves how best to move students through an arts requirement. But not everything is arbitrary. In light of the curriculum spelled out in this essay, the sequence of study is important. Introductory material must precede the appreciation of masterpieces, with critical analysis of issues coming

later. The order of learning is important because it builds systematically a sense of art and an artworld with which one thinks and feels as one encounters works of art.

Perhaps it will be asked whether at a time when art requirements in school are minimal, when in fact teachers of art and art supervisors are losing their jobs in significant numbers, and when scientific, mathematical, and technological subjects still dominate the thinking of many policymakers, it is mere idle speculation or even irresponsible to suggest the kind of curriculum described in this chapter. Is this not precisely what Jacques Barzun had in mind when he spoke of the sources of educational nonsense? He had in mind the unrealistic expectations of educational reformers. The point is well taken except for the consideration that the topic here is excellence and that we are talking about an ideal or model curriculum that spans six years (grades 7-12). In these respects, such a proposal is not unrealistic and, in truth, simply recalls several philosophies of general education published two decades ago. Moreover, should the schools fall far short of offering a significant arts requirement, then any talk about excellence is pointless. Single-course requirements in art for high school graduation and general statements of objectives are but the first of numerous steps that must ultimately be taken. Furthermore, the fact that political, economic, and social realities usually inhibit the attainment of ideals is no excuse for not stating them. It is by ideals that nations, groups, and individuals chart their courses. No less is true of the schools.

An excellence curriculum then has high expectations and sets high standards. Perhaps we can paraphrase Stanley Kauffmann's remarks about judging films: if we expect the schools, including arts education, to achieve summits, we must subject both to summit standards. Rather than say the proposal of this essay is unrealistic, one might well say that at long last we have policy recommendations that are consistent with the highest ideals of humanistic education, indicative of what the study of the arts can be, and a spur to action. If art education is a pitifully small part of the school's curriculum today and what exists is in general disarray, perhaps it is because we have neither thought well enough about it nor had sufficiently high standards.

In conclusion, an excellence curriculum for art education implies several propositions.

1. A commitment to excellence in art education is part of a commitment to general and common education at the secondary level (grades 7-12), general in the sense of being for non-specialists and common in that students learn the same concepts and skills and take similar units of work, with some opportunities to pursue personal interests.

2. A commitment to the cultivation of a disposition to appreciate excellence in art at its best—the overriding goal of an excellence curriculum—requires striving for excellence in several major contexts of teaching and learning: contexts in which students learn to understand art historically, to appreciate it aesthetically, and to judge it critically. Such contexts in turn imply a range of teaching methods alternating from didactic to heuristic to coaching to dialogic. The concepts and skills of the different contexts of instruction constitute the structure or organization of knowledge in art education.

3. A commitment to excellence in art education necessitates access to excellence throughout the secondary art curriculum, that is, access to masterpieces, exemplars, and classics of art, as well as to lesser works that are excellent within their kind.

4. A commitment to excellence in art education calls for raising and maintaining the quality of teacher preparation programs, particularly with regard to stronger academic components such as art history and aesthetics, or the humanities in general.

5. A commitment to excellence in art education implies acknowledgement of the claims of both traditional and contemporary cultures and not only the actual but also the ideal demands of individuals and society.

6. A commitment to excellence in art education acknowledges different rates of individual development and achievement within the constraints of a common education and assumes the obligation to accommodate them.

7. A commitment to excellence in art education further involves major changes in the theory and practice of art education. The preparation of teachers will have to undergo substantial reform as the profession forges a new pedagogy.

We now turn to the question of elitism, for it is characteristic of certain ways of thinking today that accenting access to excellence is considered malevolently elitist and incompatible with a democratic, egalitarian ethos. This belief has no foundation. Democratic ideals place a strong emphasis on the pursuit of excellence and its recognition.

Basic Goal: Building of a Disposition to Appreciate Excellence in the Visual Arts

Disposition fashioned from:

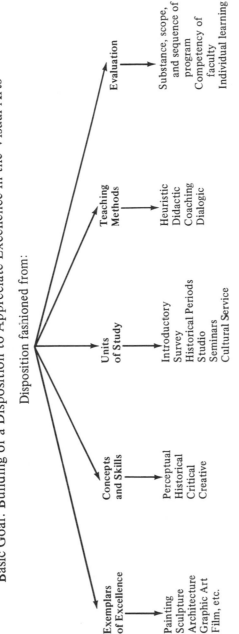

Exemplars of Excellence	Concepts and Skills	Units of Study	Teaching Methods	Evaluation
Painting	Perceptual	Introductory	Heuristic	Substance, scope, and sequence of program
Sculpture	Historical	Survey	Didactic	Competency of faculty
Architecture	Critical	Historical Periods	Coaching	Individual learning
Graphic Art	Creative	Studio	Dialogic	
Film, etc.		Seminars		
		Cultural Service		

Notes:
The relations of content and teaching methods are a function of a given learning context and its objectives. Variations in common units and content are possible in order to accommodate individual differences. Studio units alternate with academic units. The scheme addresses four basic curriculum considerations: what, when, how—and how well.

General Scheme for an Excellence Curriculum at the Secondary Level (Grades 7-12)

4 The Question of Elitism

Elite, elitist, elitism, carrying their true associations with choice or the best, are words that deserve respect and allegiance, particularly from those in hot pursuit of excellence.

Sherman E. Lee

Elitism in a just cause has its merits. . . . The best endures in the accomplishment of the masters.

Bernard Malamud

Is it elitist to stress excellence in art and art education? Is it acceptable to the democratic egalitarian ethos to speak of things eminently superior, first-rate, good of their kind? Is it consistent with democratic values to recognize and reward excellent performance? This chapter argues that the quest for excellence in art education is not elitist in any condemnatory sense and that commitment to and praise of excellence are traditional democratic virtues.

That it is necessary to raise such questions, however, attests to the pervasiveness and intensity of the conviction that excellence and democratic values are somehow incompatible. To be sure, the belief is not consistently held. In many areas of life the ideal of excellence and the recognition of excellent performance are taken for granted: writers earn awards for outstanding scholarly and journalistic accomplishment, exemplary athletes achieve well-deserved fame, and popular entertainers receive the accolades of their publics. Yet when it comes to matters of education and schooling, and particularly arts education, derision often greets those who recommend that the best that has been said, written, and created should be at the center of the curriculum. Willing to accept the fact of excellence in many other areas of life, many balk at emphasizing excellence in the teaching of art. Misgivings suddenly surface

about the reliability of value judgments and the appropriateness
of identifying exceptional performance. In support of doubts
skeptics resurrect old nostrums and marshall them against an
emphasis on standards. They ignore the debates over tastes that
go on everywhere and maintain that there is no disputing of
tastes (de gustibus non est disputandem). Despite our ability to
understand works of art, it is said that because art is visual or
auditory it cannot be explained. Oblivious to yet another tru-
ism, that masterpieces from different ages transcend their
origins and speak to subsequent eras, anti-elitists declare that
traditional art is irrelevant and has nothing to say to persons
living today, especially to members of the working class and
ethnic groups. There seems to be a basic fear that interest in
excellence reflects an unjustifiable intention to superimpose the
values of one group on the values of another, a fear that, to
repeat, appears to be more endemic to arts education than to
other subjects in the curriculum. It has even been suggested
that the current emphasis on excellence in education is merely
a trumped-up strategy to oppress minorities and stamp out stu-
dent creativity. The purpose of this chapter is to lay to rest such
unwarranted fears.

Consider first the sentiments of the anti-elitist. Even if it is
granted that the study of artistic exemplars has something of
the force this essay claims for it, is it really necessary? Should
there not be at least one place in the curriculum or school day
where there are opportunities for students to express them-
selves and make decisions on the basis of their individual inter-
ests? And what about theories that stress art as a form of play?
Did not Schiller himself in *The Aesthetic Education of Man* say
that man is truly free only when he plays? Is there not after all
something to the notion that tastes cannot be disputed? Do not
experts themselves disagree and occasionally look foolish when
works they had certified as originals are later found to be for-
geries? Is the relevance of the past an automatic and foregone
conclusion? Should not student interests and the values and
backgrounds of certain groups figure somewhere in planning
curricula and teaching? Questions such as these deserve to be
weighed carefully, although some preliminary considerations are
in order.

The notion of elitism is often opposed to that of populism

and the issues joined in phrases such as "elitism versus populism." It is more useful, however, to try to seek an accord between elitist and populist assumptions that would express a more suitable view of the arts and arts education in a democratic society, and for the following reasons.

So-called elitists are not necessarily hidebound traditionalists who instinctively turn away from popular, minority, and vanguard art. Nor do self-styled populists necessarily rule out the study of traditional masterpieces; their intention may be simply to expand the range of works young people study to include today's popular art. Neither do the differences between elitists and populists inevitably turn on the importance of standards; populists may favor the development of critical standards but, again, in connection with the study of works they assume are of more immediate interest to students. Certainly the distinction between elitism and populism cannot be based on what is popular, for seldom have "the old masters" been more popular than today. A more useful approach to the matter is to recognize what is valuble in both elitism and populism, to try, in a Deweyan spirit, to collapse dualisms and synthesize opposites. In order to do this, it is necessary to make some distinctions.

We are first of all justified in condemning *closed elites* which permit membership solely on the basis of a person's wealth, class, or social standing; these are elites of unearned privilege. But not all elites are like this. There are *open elites* of demonstrated merit which control admission by insisting on adherence to professional standards. No advanced society can exist without such elites, and even less advanced societies depend on them. The professions of medicine, law, and engineering are examples of open elites. Whatever the mistakes professionals make from time to time, it is still for sound reasons that we prefer certified engineers to design the bridges we cross and licensed physicians to write our prescriptions. Nor do we want to dilute professional standards. Professional elites come under scrutiny only when they set arbitrary admission criteria, insist on unearned benefits, or exhibit a tendency toward inordinate exclusiveness. If trust in the professions is somewhat guarded today, it is because they too, like so many other sectors of society, occasionally require remoralizing, that is, a recentering of their efforts on fundamental commitments and values.

If we think of elitism in terms of open elites and acknowledge their importance, then the term elitism loses many of its negative connotations. From an acceptance of the need for beneficial elites, in contrast to elites of unearned privilege, we may proceed to a discussion of beneficial cultural elitism. According to Stuart Hampshire, an elitist is a person who believes four propositions. The first is

> that there is a tradition of great, and of very good and interesting work, in each of the liberal arts, and that there is good reason to expect (with some qualifications) that these traditions are being prolonged into the future. Second, that at any time a minority of otherwise intelligent persons, including artists, are deeply interested in one, or more, of the arts, and have devoted a considerable part of their lives to their involvement with them, and to thinking about them. The judgments of artistic merit by such persons, who are not difficult to recognize, are the best guides to artistic merit that we have; and in fact they usually tend towards some consensus, with a periphery of expected disagreement. Third, that enjoyment of one or more of the arts is one of the most intense and most consoling enjoyments open to men, and also is the principal source of continued glory and of pride and of sense of unity for any city, nation or empire. Fourth, very often, though not always, a good artist does not create his own public within his lifetime and needs support, if he is to work as well as he might

There is little need to comment on the first proposition, which asserts that good work has been and is being done, so we pass to the second one. It points out that not only connoisseurs, art historians, and art critics constitute the elites that make distinctions of value among works of art; artists also participate in the formation of critical opinion. Indeed, the historical record abounds with their judgments of past and contemporary art and, as Leo Steinberg has pointed out, the judgments of artists are often the harshest of all.

With some notable exceptions, the judgments of critical elites have been remarkably stable; they tend to withstand the test of time. There is now a core of classics and masterpieces that is accepted by those who work in the world of art; controversy is less about the core than about its periphery. And movement between periphery and core does not occur haphazardly; it is usually attended by intensive critical debate. Witness, for example, the controversy that is currently raging over interpretations of modernism.

The third proposition of elitism also features what is difficult to deny; the experience of art at its best is indeed one of the most intense and often most consoling forms of human gratification, or, as this essay emphasizes, it is a significant and worthwhile experience. It is precisely such gratification that Kenneth Clark had in mind when he expressed his belief that even today "the majority of people really long to experience that moment of pure, disinterested, non-material satisfaction which causes them to ejaculate the word 'beautiful,' " an experience, he went on to say, that is "obtained more reliably through works of art than through any other means." An enjoyment of the beautiful does not, of course, exclude an appreciation of the dark and tragic aspects of artworks, a fact we occasionally forget until we reflect on our own experience and recall the ominous character of numerous masterpieces.

It is also apparent that art represents cultural continuity, is a symbol of civilization, and an expression of national and civic pride, another proposition of Hampshire's explanation of elitism. Nations and cities build and maintain museums and performing arts centers for more than purely aesthetic reasons. Next to its record of humanitarianism and compassion nothing reflects the quality of an era more tellingly than its cultural achievements. The identities of New York, Chicago, and Los Angeles are as dependent on these cities' museums, public art, and symphony orchestras as on their investments and commercial enterprises.

It is a popular misconception, moreover, that elitists yearn only for the art of some past golden era and turn their backs on contemporary art. As their writings attest, elitists of the sort Hampshire talks about easily traverse cultural spaces and periods. Thus "Style and Medium in the Motion Pictures" by Erwin Panofsky, a distinguished art historian, is one of the most anthologized essays on film. William Arrowsmith, a classical scholar, discovers value in both Homer's *Iliad* and Alain Resnais's film *Hiroshima, mon Amour*; the latter, he thinks, unconsciously imitates the ancient work. Meyer Schapiro finds something to remark in Romanesque sculpture and in modern painting. Leo Steinberg is fascinated with the perplexities not only of Michelangelo but also of Jasper Johns. Jacques Barzun's historical knowledge of the last 150 years justifies his saying that there

have been no new ideas in the world of art for the past half century. The elitist's supposed submission to the dead hand of the past is in short a myth. Journeys into the past are made not only for the intrinsic values of the voyages themselves but also for the insight discovered into contemporary problems. Rather than regard such scholarship with suspicion, we should accommodate it and impart it in appropriate ways to our students.

That elitists are correct in setting store by critical judgment is also apparent, and this suggests that it is indeed proper for tastes to be disputed. At issue in the question of taste is not the obvious fact that tastes differ and are contested but that assertions made in behalf of one's taste are subject to rational scrutiny. Indeed, persons often welcome help in thinking about their preferences and upon reflection may well decide to alter their opinions and subsequently their tastes. Hampshire even goes so far as to say that to treat persons as if they know what they want or ought to know is in effect to treat them as less than human. Being reticent about what we think is valuable thus does nothing to alleviate the indecisiveness of the young. Learning to appreciate the excellence of art is after all part of learning to become self-sufficient in the cultural domain. We tend to forget, as Harry Broudy has pointed out, that the cultural heritage is revolutionary as well as conservationist; it not only contains the fruits of systems of thought and creativity but also the critical tools for appraising these fruits. Armed with the standards of judgment and the perspectives of the cultural heritage, youth may be less susceptible to the stereotypes of pseudo-art and be able to demand better. Certainly there can be no doubt that the level of taste in a society is important; it will affect not only what artists create but what people will be encouraged to appreciate. William Faulkner once remarked that a low level of writing in a society may not be entirely the fault of writers and that literature may not improve until readers do. We must be concerned therefore about that part of the cultural environment which consists of the general skill and ability of readers. Is there any question that the same situation may be influencing the condition of the visual arts today?

The elitist says that the enjoyment of excellent art is one of the higher forms of human enjoyment, not *the* highest, but

one that nonetheless ranks high among the features of the good life. The elitist is also correct in this belief. If the pursuit of happiness is a democratic right, then providing the young with opportunities to appreciate art for its capacity to induce worthwhile experience is hardly undemocratic. Indeed, how insensitive *not* to acquaint the young with some of humankind's finest achievements.

In summary, nothing in Hampshire's four propositions suggests there is anything maleficent about elitism. There is no implication that elitists hold themselves socially superior or are insensitive to minority or ethnic art, contemptuous of popular culture or contemporary art, or antidemocratic. Certainly there is no indication that access to excellence and the cultural heritage should be limited to certain groups or that people from all walks of life are incapable of acquiring a taste for the best. It must be concluded that much of what elitism is criticized for is not necessarily part of it. While it is possible to speak of harmful, undemocratic elitism, it is *beneficial* elitism that Hampshire characterizes, an elitism that sets store by a knowledge of the cultural tradition, the value of cultural continuity, the act of critical judgment, and excellence. It is an exceedingly crimped view of human nature which asserts that such values are beyond the ken of the large majority of persons. Let us now turn to a discussion of populist beliefs.

Although one frequently encounters the terms "populist" and "populism" in discussions of art and art education, there is no well-formulated theory of cultural and educational populism rooted in serious populist thought. From a number of writings, however, it is possible to infer that a populist believes one or another of the following propositions, and perhaps some populists believe all of them.

One proposition asserts that works of art are so totally the products of the conditions and prevailing ideologies of a certain time and place that they are both inaccessible and irrelevant to anyone whose outlook was not shaped by similar circumstances. Only works from one's own time, or better, from one's own social class have any meaning. This leads to a second proposition: those who stress the study of traditional exemplars of art commit acts of political oppression. They alienate people from their cultural roots, denigrate their individual preferences, and

deprive them of a sense of self-worth and pride. It should come
as no surprise then that a third proposition of populism accepts
a thorough-going relativism in matters of artistic judgment. It
holds that there are no defensible criteria by which one work of
art can be judged superior to another. The fourth proposition
follows from the others: people should be given the kind of
culture they want and not what others think they should have.
Such propositions stand in sharp contrast to the propositions of
elitism discussed by Hampshire. How well do they stand up to
critical examination?

Concerning the alleged inaccessibility of artworks from the
past because of our inability to engage them in the ways those
who lived at the time did, it is possible to say three things.
Kenneth Clark's examination of the art-historical record reveals
that, true, art has usually been made by an elite for an elite to
celebrate the values of an elite, that is, an elite of skillful artists
and craftsmen who celebrate the values of the dominant groups
in a society. Created by an elite for an elite, says Clark, but none-
theless enormously enjoyed by the large majority of people.
The populace of a city often followed with great interest the
career of an artistic commission and gladly joined in the festivi-
ties that attended the work's dedication. The reaction of the
citizens of Siena to the completion of Duccio's great altar-
piece, the *Maestà*, in the fourteenth century is a typical instance
that Clark cites. If one were to look for a comparable reaction
today, one could find it in the pride expressed by the populace
of Reggio di Calabria in the classical sculptures discovered in
the waters off southern Italy. Interest in these so-called Warriors
of Riace generated a national debate regarding whether the
works should be housed in Florence, where more people would
see them, or in their place of discovery, with Reggio di Calabria
finally winning out.

There is, of course, a certain element of truth in the inacces-
sibility thesis. Neither we nor our successors will ever be able
to experience the classical monuments of antiquity or the reli-
gious art of the Middle Ages in the ways the people of those
times did. Nor can we recapture, say, the excitement that
attended the Renaissance humanists' rediscovery of ancient
texts. It is nonetheless an incontestable fact that the classic
works of the past—its exemplars of sculpture, painting, archi-

tecture, and decorative arts—have proven their power to move and delight generation after generation, including our own.

In illustration of this commonplace, consider the following. In discussing the problems of developing a student's appreciation of Christian art, for example, the Byzantine icon known as the *Vladimir Mother of God* (c. 11th-12th century), which depicts Mary and the Christ Child, Nelson Edmonson asks why he, an agnostic, can nonetheless be moved not only by the composition of the work but also by its expressive meaning. After all, the work was intended to serve mainly a religious function. To the faithful the veneration of icons is related to the goal of receiving grace and the fulfillment of God's prophetic vision. But whatever its religious function and meaning, Edmonson writes that for him the icon "manifests mankind's remarkable creative ability to focus in one potent image, and thereby raise to a shared consciousness, the common human condition of suffering alleviated by love." Persons of all beliefs or of no belief can thus experience "a sense of being an integral factor in a larger human drama, of having, as it were, an extended historical companionship." In other words, by virtue of their being highly condensed tokens of the radical complexity of human experience, works of art transcend dogma and their own time. Edmonson thus provides yet another example of what we said in chapter 2: art at its best reveals the complexity of life and expresses a deep sense of human values. What we respond to is the recognition of a shared humanity.

Another proposition of populism, that all aesthetic judgments are expressions of personal preferences and thus unreliable indicators of quality and stature, also contains an element of truth but requires an effort of self-deception to maintain consistently. The discussion of the critical writings of Jakob Rosenberg, Kenneth Clark, Meyer Schapiro, and Sherman Lee in chapter 2 provides ample testimony in behalf of the possibility of making convincing judgments of excellence. That it is more difficult in the arts to gain consensus on the criteria of excellence than it is in the sciences does not rule out the possibility of achieving sound estimates of aesthetic value. Populists go wrong in conveniently overlooking those clear-cut cases where refusal to acknowledge superior attainment flies in the face of common sense. There are, after all, good reasons why

such terms as novice, amateur, immature expression, hack work, and pseudo-art came into the language; all refer to performance that falls beneath a certain standard. Rather than casting aspersions on the opinion of those who know quality when they see it, we should welcome it for its assistance in opening our own eyes.

What about the charge of political oppression? Granted all of the above, is it still not the case that one group of persons— those possessing expert qualifications—is imposing its values on others who are being persuaded, initially at least, to accept things pretty much on faith? First of all, the choice of terminology prejudices matters. "Imposition" with its sense of the forcible and illegitimate is misleading. Curriculum decisions are often the result of a democratic decision-making process that involves legitimate parties to the deliberations. And the trend in education today is to encourage more not less participation. To be sure, experts enjoy no special political prerogative. If they influence decision making it should be because their expertise is helpful in setting and realizing worthwhile goals. The charge of political oppression would in fact lose its plausibility if instead of suspecting imposition we spoke convincingly of providing access, if instead of fearing the suppression of individual interests we emphasized liberating young minds from nature for culture, and if instead of denouncing the wielding of state power we spoke of enfranchising the young in matters of understanding and appreciation. When one takes these goals and results into account, the language of political oppression assumes a strained quality. To place within the grasp of persons that which has the capacity not only to intensify their experience but also to enlarge the scope of their awareness is hardly facist or totalitarian, and it is perhaps time thoughtful persons recognized such cant for what it is.

Regarding the populist proposition that people should receive the kind of culture they want, it may be reiterated that persons, especially the young, are often uncertain of their tastes and need to know something of the range of what it is possible to enjoy and admire before they can make up their own minds. Certainly it is presumptuous, to say the least, to assume that given the opportunity to understand and appreciate the best, persons will turn their backs on it. In any event, it would make

a mockery of an excellence curriculum to ground it in a principle of untutored personal preference.

If we are to achieve something of a synthesis between elitism and populism, we should also acknowledge certain virtues of populism. Populism is the watchdog that keeps elitism on its guard and prevents it from becoming too impressed with itself. As a viewpoint that casts its net wide and far, it reminds us that excellence is found not only in one's own cultural heritage but in other worlds and civilizations as well. In this respect populism often expresses genuine regard for the arts of all people. Populism further reminds us that the arts of everyday living make rightful claims on our attention. All of these virtues should not be overlooked, and an excellence curriculum in art education does well to keep them in mind. To repeat, what we want is a synthesis of beneficial elitism (an open elitism in a just cause) and beneficial populism (a populism that endorses access to excellence for all). Such a synthesis would be truly worthy of a democratic society. It is one that would emphasize the popularization and humanization of knowledge and the pursuit of excellence by means of providing access to the best.

To gain a better appreciation of the virtues of beneficial elitism, we might pause briefly to look at the elitist-versus-populist controversy in Great Britain, whose history of class distinctions and conflict gives the controversy a special intensity.

Like their American counterparts, British populists celebrate the "art of the people," by which they usually mean the art of the working class. Believing that it is more important for people to appreciate, and create works for, the culture of their own group than to pay homage to traditional culture, populists consider efforts in this latter direction fraudulent. British opinion on matters of culture tends to have a heavy ideological coating that reflects the ideas of the political Left. Yet even admirers of British working-class culture are beginning to say that populist advocates often misinterpret the aspirations and capabilities of working-class people. The basic mistake, writes Richard Hoggart, himself of working-class origin and a respected adherent of the political Left, consists of confusing sincerity, good intentions, and humane social services with art and artistic merit. In British populist writing, art is assimilated almost exclusively to com-

munity social activities (with the consequent effect of devaluing individual artistic creation and appreciation), while at the same time the concept of art is expanded to include practically everything (which has the effect of discrediting truly exceptional, valuable, and excellent things). But Hoggart points out that, historically, the British working-class tradition of adult education has expressed aspirations that supplement and transcend communitarian values. "Among its many great qualities," he writes, is "the belief that people should be able to stand up and reach for the best and the most demanding," and that given opportunities to stretch their capacities ordinary people will reveal "far more abilities than either a closed elitism or an ill-thought-through communitarianism had realised. So they have a right to the best, no less."

Coming from a representative of the political Left, Hoggart's remarks have special force. They express impatience, nay anger, with the impoverished educational imagination of the far Left and recall Paul Goodman's criticism of the intolerance of the youth culture in the 1960s in this country, a group he had at one time championed. One is also reminded of Chester Finn's rejection of the charge that the excellence-in-education movement discriminates against minorities. He writes that the closer one actually gets to members of minority groups the more one realizes that they understand the importance of high standards and that they expect their children to be held to them along with everyone else.

Hoggart's animadversions further recall Charles Frankel's observations on what he called the new and the old egalitarianism. Frankel, whose ideas are properly characterized as liberal in the best sense of the word and whose book *The Democratic Prospect* demonstrates that he understood the nature of democracy better than most, points out that the new egalitarianism attempts to replace the principle of equal opportunity with the demand for guaranteed equality of results. He reminds, however, that there is an older ideal of egalitarianism that also valued equality but which recognized the importance of differences, partisan feelings, and even social stratification. This awareness implied, among other things, the capacity "to tell the genuine article from the fake" and to understand "the need in every society to give public recognition to things noble and

excellent lest everything in the society's culture be regarded as disposable." The old egalitarianism, Frankel writes, does not subvert the principle of equality; it merely sets limits on it and keeps it sane. Arthur Schlesinger, Jr., in effect echoes this sentiment in his reflections on the American tradition of liberal thought and action. He writes that the concerns of liberalism are not only political and economic but also moral and cultural. They are as much associated with Whitman, Emerson, Thoreau, and Melville as with Jefferson and Jackson, in short "with all those who insisted on holding America (and themselves) up to stringent standards"

In emphasizing access to excellence and by paying the majority the compliment of believing them capable of attaining it, traditional egalitarianism follows the great nineteenth-century cultural critic (and school inspector) Matthew Arnold. For Arnold, the true apostles of equality are those "who have had a passion for diffusing, for making prevail, for carrying from one end of society to another, the best knowledge, the best ideas of their time; who have laboured to divest knowledge of all that was harsh, uncouth, difficult, abstract, professional, exclusive; to humanise it, to make it efficient outside the clique of the cultivated and learned, yet still remaining the *best* knowledge and thought of the time, and a true source, therefore, of sweetness and light." There can be no better ideal for democratic education. Indeed, Lawrence A. Cremin, the eminent historian of American education, suggests that a commitment to the popularization and humanization of knowledge in the Arnoldian sense defines the genius of American education.

In summary, Frankel's reference to things "noble and excellent," Hoggart's "access to excellence," Schlesinger's "stringent standards," and Arnold's "the *best* knowledge and thought of the time" all find a place in a discussion of excellence in art education.

If the belief that the ideal of excellence in art education is undemocratic has no basis, neither does the objection that it takes the fun and excitement out of schooling and replaces, as it were, imaginative play with too much piety. Playfulness and piety, however, are the two faces of any kind of intellectual activity, including artistic creation and aesthetic appreciation. If it seems that this essay tips too much toward piety, it should be

pointed out that the contribution to our understanding afforded by play theories of art from Schiller through Huizinga to Herbert Read has been taken into account. And although it is probably true, as Monroe Beardsley suggests, that we should approach a work in something of a suppliant mood, he also points out that the aesthetic experience of art tends to be marked not only by a feeling of solemnity but also by exhilaration, not only by intense concentrated attention but also by relief from practical and pressing preoccupations, not only by the task of making conflicting stimuli cohere but also by the gratification that derives from doing so. One can even say, as Harold Osborne does, that art provides a necessary leavening in an inherently pragmatic or instrumentally oriented society whose technological imperatives tend to have an adverse effect on aesthetic values. Indeed, if there is anyone who takes the inherent delight out of art and art education, it is the political ideologist who insists that art be a form of social criticism and an incitement to revolution.

Finally, the claim that "the people's choice" or "the student's choice" should take precedence over knowledgeable opinion and experience (an assertion made practically no place else in the curriculum, certainly not in mathematics or science education) not only imputes an unrealistic maturity to developing minds but also takes a condescending view of young people's potential for transcending their present levels of knowledge and taste. This point is understood by Sir Roy Shaw, a good Arnoldian and erstwhile Secretary-General of the British Arts Council, who thinks that populist impulses are often latently elitist in the condemnable sense. They imply there are certain groups in whose behalf populists purportedly speak but who because of their weaker constitutions must be given an art that is watered down and less demanding, while high culture is reserved for others. Similarly, Hilton Kramer remarks that the populist's hostility to high art is itself a form of elitist contempt for the masses who daily demonstrate their appetite for serious art. What is needed then is not self-serving ideology but intelligent criticism and adequate education that will enable persons to appreciate quality in art. Those who have been members of groups in whose behalf populists purportedly speak and who were given the opportunity to cultivate a taste for the best

know the truth of Shaw's and Kramer's observations and the error of populist thinking. Marva Collins also knows it, as will her students when they mature.

Perhaps no one has made a more eloquent case for the compatibility of artistic excellence and democratic values than Robert Penn Warren in his 1974 Jefferson lecture in the humanities titled *Democracy and Poetry*. Since Warren means by poetry not only literature but art in general, his views make a fitting conclusion to this chapter.

After saying that the development of selfhood is at the heart of a democracy's efforts and that it implies a sense of felt significant unity within onself, Warren addresses the common retort that nondemocratic societies often produce good and excellent art and that this fact refutes any necessary relation between art and democracy.

Warren agrees there is no necessary relation, but he points out that even in a nominally democratic society such as fifth-century Athens, which self-consciously celebrated aristocratic ideals, a concept of self emerged that featured man as the measure of all things. What is more, a unique sense of selfhood is present in all great art irrespective of the kind of society in which it was created or that society's ideology. Perhaps we might say that we sense it in what Osborne calls the expression of a universal aesthetic impulse to create order and form. True, individual self-expression has not been valued in all ages, nor is it valued by all cultures today, but even in the Middle Ages, as Meyer Schapiro points out in his study of Romanesque sculpture, one can detect a strong individual presence. By suggesting that all great art is an expression of a universal aesthetic impulse as well as an expression of individual selfhood, Warren in effect confers relevance on the entire cultural heritage. And he helps us to understand why William Arrowsmith thinks the cultural heritage literally trembles with relevance.

Warren goes on to explain how in advanced democratic societies it is becoming increasingly difficult to keep alive and realize the ideal of selfhood. New determinisms—economic, psychological, technological—are calling into question the viability of the concept of self and are encouraging persons to think of themselves as puppets of larger controlling forces, mere "human

muck" as Mark Twain has one of his characters remark. But this may be an unnecessarily pessimistic assessment of the human estate, for Warren believes that if we can ever learn to use leisure to invigorate rather than dissipate the self, modern society will be able to create a dynamic favorable to the realization of genuine selfhood.

Warren thinks that in a society increasingly given to the standardization of practically every aspect of life, art performs two crucial functions: one is to provide the self with opportunities for the unique expression of its energies in artistic creation and aesthetic appreciation; the other is to serve as a valuable critic of society's dehumanizing tendencies. In a significant amount of modern literature, though it is found in the other arts as well, one experiences a severe indictment of the conditions that inhibit the expression of individuality and prevent the attainment of a sense of self. Good art, that is, not only describes the conditions and consequences of human alienation but through its example and vision offers alternatives to them.

It was to be expected that in an essay on art and democracy it would only be a matter of time until Warren would address the question of elitism. Since excellent art represents a superior achievement and its effects tend to be commensurate with its quality and stature, Warren assumes that art has an elite status. But obviously it is a beneficial elitism. Nowhere outside art can we find a more impressive and heroic attempt to sustain and nourish those qualities that Trilling called variousness, possibility, complexity, and difficulty— qualities so needful to a society in danger of yielding to excessive standardization and the temptations of ideology. In short, says Warren, art is a realm of human endeavor that democracies ignore at their peril. The completed art object is valuable not only as a vital affirmation and image of the organized self, but also as "a permanent possibility of experience" that "provides the freshness and immediacy of experience that returns us to ourselves."

In concluding this discussion of elitism and populism, it is worth pointing out that while democracies value the common man, they do not value what Ortega y Gasset called the commonplace mind, a mind that not only knows itself to be commonplace but also proclaims the right to impose its commonplaces whenever possible. Matthew Arnold also realized that

with the coming of mass-democratic society the freedom and energy of large numbers of people would be to no avail unless they were employed in the service of an ideal higher than that of the ordinary self, that is to say, unless they were employed in the service of the best possible self. It is thus the potentiality for becoming uncommon that is important. In this respect, art is one of those things of the world that at its best is a perpetual reminder of the possibility of transcending the ordinary; it constantly calls us away from a pedestrian life.

5 Initiatives toward Excellence

Human expression cuts across written and spoken language, theater, song, and visual art. There is much common ground in these attempts of man and woman to explain their predicament. Yet English, music, and art usually proceed in as much splendid isolation as do mathematics and science. This is wasteful, as aesthetic expression and learning from others' attempts to find meaning are of a piece. All need representation and benefit from an alliance.

Theodore Sizer

We have made the case for excellence in art and art education and resolved any doubt about the compatibility of the pursuit of excellence with democratic values. The remainder of this essay discusses a number of initiatives that are consistent with building an excellence curriculum for art education at the secondary level. Initiatives will be discussed under three headings: initiatives in the excellence-in-education literature; initiatives in the theoretical literature of art education; and initiatives for the future. One of the conditions that suggests some genuine progress can be expected in the reform of art education is a readiness on the part of many art educators today to entertain recommendations for substantive reform.

Initiatives in the Excellence-in-Education Literature

The document that issued the call to reform this time, *A Nation at Risk*, is hardly the best statement on arts education among the reports, but it does mention it here and there. For example, we read that knowledge of English, mathematics, science, social studies, and computer science "together with work in the fine and performing arts and foreign languages constitutes the mind and spirit of our culture." However, this way of mentioning the arts was sufficient for most reviewers to omit any reference to

the arts as a new basic subject, and all that many know of the reports is what numerous summaries and abstracts prepared for meetings and conferences say about them. In referring to the quality of life, *A Nation at Risk* further states "that an over-emphasis on technical and occupational skills will leave little time for studying the arts and humanities that so enrich daily life, help maintain civility, and develop a sense of community," whereas "knowledge of the humanities . . . must be harnessed to science and technology if the latter are to remain creative and humane, just as the humanities need to be informed by science and technology if they are to remain relevant to the human condition." One objective of English study is to "know our literary heritage and how it enhances imagination and ethical understanding, and how it relates to the customs, ideas, and values of today's life and culture." Conventional rhetoric, to be sure, but such passages contain the seeds for a justification of arts education as a basic subject. Unfortunately, the discussion never rises above the level of highly general statement.

Five other reports—actually three are studies, one a manifesto, and the third a set of recommendations—do somewhat better; for example, John Goodlad's *A Place Called School*, Ernest L. Boyer's *High School*, Theodore Sizer's *Horace's Compromise*, Mortimer Adler's *The Paideia Proposal*, and the College Board's *Academic Preparation in the Arts*.

Chapter 3 remarked that in thinking about an excellence curriculum for the secondary grades, we should consider the larger setting in which it is embedded, a setting that includes not only the dynamics and ambience of a given school but also the immediate community, school district, and even state. This environment considerably influences the ways schools try to achieve their various objectives. Living in an era of ecological awareness we should, in other words, attempt to see things as interdependent components of systems trying to maintain equilibrium while undergoing change. Such awareness is leading to a better understanding of the ways schools try to achieve their goals and reform themselves. Perhaps no single work is likely to contribute more to an ecological view of schools than John Goodlad's *A Place Called School*, an ambitious and impressive multiyear study of schooling in America. If nothing else, Goodlad's study should lay to rest conspiracy or villain explanations of the

schools' ineffectiveness which have tended to dominate educational criticism for the past few decades. As schooling is interdependent with other sectors of society and reflects and shares its problems, no single cause, Goodlad emphasizes, can be cited for its shortcomings. Goodlad further exposes numerous misconceptions about schooling that derive either from misinformation or simply axe grinding.

The upshot of Goodlad's study is that the schools reflect the dominant values and attitudes of the larger society and attempt to change only when forced to do so. These values and attitudes are not expressed in the statements of higher purpose subscribed to by practically all schools but in the operative values implicit in the circumstances of schooling—for example, in the contents of the curriculum and methods of teaching, in a school's attitude toward equality and access, and in its disposition toward change. The degree of seriousness and caring about teaching and learning is also important. Goodlad is conscious of the dramatic progress that has been made in providing access to schooling and he remains inherently optimistic (optimism, he says, goes with the educator's territory). But from an examination of research on a sample of schools he presents a picture of the schools that might well prompt a prospective teacher or an educational reformer to have second thoughts about choosing teaching as a career or about trying to improve schooling.

> Those women—and men—who do enter teaching today work in circumstances that include some gain in their autonomy in the community accompanied by some loss in prestige and status; an increase in the heterogeneity of students to be educated, especially at the secondary level; increased utilization of schools to solve critical social problems such as desegregation; a marked growth in governance of the schools through legislation and the courts; continuation of relatively low personal economic return; limited opportunities for career changes within the field of education; and continuation of school and classroom conditions that drain physical and emotional energy and tend to promote routine rather than sustained creative teaching.

That is not all. The concerns of teachers and students diverge in important ways. Teachers place a strong emphasis on the academic function of schools whereas students are more interested in vocational training and grades needed for graduation. Even more important to large numbers of students is the nonaca-

demic side of school life that consists of social activities and sports. For all the despair and pessimism an awareness of such characteristics of contemporary schooling can generate, Goodlad nonetheless writes that "to think seriously about education conjures up intriguing possibilities both for schooling and a way of life as yet scarcely tried."

What Goodlad in effect concludes is that neither the spirit and methods of progressive education, the curriculum reform movement of the late fifties and sixties, nor the ideas about open education of the seventies have had any appreciable effect on the quality of schooling. While efforts to promote significant learning are more discernible during the early years, they are much less apparent at the secondary level. Variations from dreary routines of teaching are offered by many arts and vocational education classes, but students think that such classes, though enjoyable, are easy and unimportant.

Regarding the teaching of the arts, Goodlad found a general condition of disarray and a lopsided emphasis on manual skills and performing activities—for example, on drawing, painting, ceramics, singing, dancing, pantomime, puppetry, acting in plays, filmmaking, embroidery, weaving, crafts, graphics, photography, and jazz. Seasonal projects are popular and an inordinate amount of time is spent on rehearsals for plays and sporting events. As art instruction is mainly technically oriented, little attention is paid to works of art as objects capable of being admired for their excellence. Overall, says Goodlad, there is too much "coloring, polishing, and playing" and "a notable absence of emphasis on the arts as cultural expression and artifact," which is to say there are few opportunities to develop sophistication in the appreciation of the arts.

Goodlad's recommendations for improving secondary education recall reports on general education from the forties and fifties and emphasize a degree of choice in an otherwise common and balanced curriculum. His curriculum consists of seven domains (if one counts physical education) of instruction distributed over the secondary years approximately as follows: mathematics and science (18%); literature and language (18%); social studies (15%); the arts (15%); the vocations (15%), physical education (10%); and individually selected studies (10%). There could be some variation in these percentages, but, again,

not everything would be prescribed. The seventh domain could consist of further concentration in one of the core areas, including the arts. It may well be, says Goodlad, that the seventh elective domain could prove to have more lasting value for students, although he doesn't think students should be permitted too much choice. The reason is that it is difficult to become interested in something if one knows little or nothing about it. So far as individual differences and the question of common learnings are concerned, Goodlad thinks that the research on the topic suggests variability is more relevant to modes of teaching than to areas of study. Schools, moreover, should keep records on each student to determine the extent to which a student's program deviates from an ideal or prototype program. Goodlad's domains bear resemblance to the basic subjects and fundamental areas of knowledge and appreciation found in *A Nation at Risk*, Boyer's *High School*, and Adler's *The Paideia Proposal*, and his humanistic sentiments are similar to those expressed in Sizer's *Horace's Compromise*.

Unlike Adler, however, who, out of touch with trends in art education, emphasizes that making art and performing activities are as important as talking and thinking about art, Goodlad realizes that there is already far too much making and performing in today's art education. He therefore stresses that such activities should be supplemented with the cultural study of the arts. Because he wants his study to be more of a goad to reflection about conditions of contemporary schooling and needed substantive reform, Goodlad does not detail his recommendations for an arts curriculum. Rather, for contemporary progressive thinking about arts education he refers, in passing, to a volume commissioned by his study of schooling. But everything considered, Goodlad's book bodes well for art education, and, in the terms of this essay, it is an important initiative toward excellence in art education.

Mortimer Adler's manifesto, *The Paideia Proposal*, written on behalf of the members of the Paideia Group, is dedicated to Horace Mann, John Dewey, and Robert Hutchins, who form but one of several trinities we encounter throughout this brief tract. The report is Deweyan in spirit in stating that the purpose of schooling is to prepare youth for further learning and more growth. The legacy of Horace Mann is discernible in the com-

mitment to the public schools and to Mann's belief that public education is the gateway to universal equality. The debt to Robert Hutchins is acknowledged by Adler when he quotes Hutchins's conviction that "the best education for the best is the best education for all." Adler's distinctive mark is his assumption that the basic similarities among individuals are more important than their differences, which he thinks supports an argument for a common rather than a differentiated curriculum. He believes that whatever individual differences there are among students can be accommodated in a context of sameness. What is important to realize is that all children "have the same inherent tendencies, the same inherent powers, the same inherent capacities." And since the meaning of social equality implies the same quality of life for all, there should be the same quality of schooling for all. Adler stresses that he is not recommending a monolithic educational system; reform must be achieved at the community level.

We encounter the second trinity in connection with the uses of schooling for self-governing citizenship, for earning a living, and for the enjoyment of things of the mind and spirit. The mind may be improved in three ways: through the acquisition of organized knowledge in the most fundamental areas of human learning, for example, in language, literature, fine art, mathematics, natural science, history, geography, and social science; through the development of intellectual skills, for example, those of reading, writing, speaking, listening, observing, measuring, estimating, and calculating; and through the enlargement of understanding and aesthetic appreciation. The emphasis throughout such a curriculum is on the study of the individual work, the development of a common vocabulary of ideas, and a movement from easy to complex learning.

Adler's discussion continues with yet another triad about modes of teaching: the didactic mode, which consists of the imparting of knowledge or teaching by telling; the mode of coaching, which involves teaching or showing how to acquire basic skills and calls for drill and practice; and the maieutic or Socratic mode, which is essentially dialogue that helps give birth to ideas. All three methods—didactic, coaching, maieutic—should be used at all stages of intellectual, moral, and aesthetic development in trying to raise minds toward higher levels of understanding and appreciation.

It is in connection with the goal of enlarging the understanding and imagination that we find what discussion there is of the arts. In the main, the emphasis in arts education should be on the understanding and appreciation of the particular or outstanding work of fine art, whether literary, musical, or visual, but an additional treatment is required if the arts are to be "appreciated aesthetically" or "enjoyed and admired for their excellence." Appreciation should be aided directly through creative and performing activities. Students should paint pictures, compose poetry, act in plays, and dance. The arts should also be discussed critically in seminars where ideas and assumptions can be examined and clarified.

In what seems like a special appeal to art educators, Adler underlines the importance of creative and performing activities for directly enhancing aesthetic appreciation. But in view of the lopsided emphasis Goodlad found on making and playing in arts education, it needs to be stressed that viewing, talking, and thinking about art are as important as making art and performing in musical groups or plays. It is mildly amusing, moreover, to see Adler committing what fellow Paideia Group member Jacques Barzun in his *The House of Intellect* calls the professional's fallacy, that is, the mistaken belief that one must know how to practice the craft of a subject in order to understand and appreciate it.

Not surprisingly, everything in Adler's manifesto comes together in three columns that feature three modes of learning (acquisition of organized knowledge, development of intellectual skills, and enlargement of understanding and appreciation) and three modes of teaching (didactic, coaching, and maieutic).

Adler further discusses auxiliary studies that consist of health and physical education, manual work, and career exploration, although he rules out job training. He also acknowledges the importance of remedial instruction prior to entering school and in schooling itself for those who need it. In connection with the preparation of teachers, Adler voices the usual plea for fewer education courses and more work in the liberal arts and sciences. This recommendation, however, conveniently overlooks the sad state of undergraduate education documented in recent reports and, in fact, lamented elsewhere by Adler himself.

It is less important to discuss all of Adler's recommendations

than to see his proposal as a significant contribution to the fur-
therance of excellence in art education. It is important to know
that a renowned philosopher writing on behalf of a distinguished
group of scholars and educators believes that the arts have the
capacity to expand human experience and contribute to the
good life and therefore should be a basic subject in a core
curriculum. Readers will recognize certain similarities between
Adler's model curriculum design and the model for the secon-
dary grades described in chapter 3, but in truth the design there
draws as much on conventional curriculum wisdom and com-
mon sense as on Adler's ideas.

Another study, Ernest L. Boyer's *High School*, sponsored by
the Carnegie Foundation, was mentioned in the introduction as
a work that not only stresses the study of the arts as a basic
subject of a core or common curriculum but also contains rec-
ommendations for major changes in the way we currently train
teachers of art for the schools. Now the excellence curriculum
described in the essay at hand would similarly involve a major
overhauling of teacher preparation, especially in its insistence
on a much stronger component of work in the humanities. But
whether Boyer's reform of teacher education requires radically
new institutional arrangements is of less moment here than is
the observation that yet another significant instance of recent
educational thought no longer considers the arts marginal to
schooling.

Speaking in accents different from those of *A Nation at Risk*
and looking askance at other studies that stress improvements
only in mathematical, scientific, and technological areas, Boyer
asks that more attention be paid to the love of learning for its
own sake, to the use of learning to improve the quality of life,
and to the pursuit of excellence as well as equity. Sensitive to
the circumstances that inhibit genuine teaching and learning and
to the limitations of standard achievement tests for measuring
the quality of schooling, Boyer, after ritualistic acknowledge-
ment of progress, goes on to say that schools today really have
no coherent goals and are in effect adrift. To set things on a
steady course, objectives must be clarified, curriculum offerings
considerably pared down, and the conditions of teaching im-
proved. Most of all, a core of basic subjects should be created.
Of what should such a core consist?

Broadly defined, it is a study of those consequential ideas, experiences, and traditions common to all of us by virtue of our membership in the human family of a particular moment in history. These shared experiences include our use of symbols, our sense of history, our membership in groups and institutions, our relationship to nature, our need for well-being, and our growing dependence on technology.

The particular components of the core are English, literature, the arts, foreign languages, civics, science, mathematics, technology, and health education. As if to insure that they will be included in summaries of the core, Boyer places literature and the arts before the sciences, mathematics, and technology. (It will be recalled that owing to its phrasing, the arts tend to be left out of summaries of *A Nation at Risk*.)

While it is questionable to separate literature from the arts—literature after all is a cluster of arts, e.g., poetry, novels, and plays—Boyer and most of the other reports do so. He writes that in addition to being carriers of the cultural heritage and a measure of civilization, the arts are especially suited to express a range of human emotions. If there is anything approaching a definition of art or a notion about its basic function in his brief remarks, it is that art is a nonverbal form of communication that educates the emotions and validates feeling in an increasingly insensitive world. Such a view of art's role is common enough, although it does raise a number of questions that continue to puzzle students of art. What, for example, do works of art communicate that verbal discourse does not? What does it mean to validate feeling or to educate the emotions? What often seems obvious isn't always so, and even E. H. Gombrich cautions against the equation of art with communication. The ability to educate the emotions, moreover, would seem to be a more characteristic function of literature than of the visual arts. There is also the question, raised by Lionel Trilling, whether good art always tells the truth, or the best kind of truth, about the self and its emotions. We do not, of course, expect to find a well-conceived aesthetic theory in the kind of book Boyer has written, and if such questions are briefly raised here, it is only to underline once more the fact that the reports and studies in question are of little help in conceptualizing art education for purposes of teaching and

learning. The importance of Boyer's study for this essay lies rather in the prominence it gives to the study of the arts.

In substance, scope, consideration, and flexibility, Boyer's curriculum for the high school stands out among the reports in question and in the respects mentioned bears more resemblance to Goodlad's recommendations than to those of either *A Nation at Risk* or *The Paideia Proposal*. Especially during the last two years of high school, Boyer would depart from strict requirements and permit a pattern of requirements and electives. A unit of service is also recommended in order to give students a sense of institutional realities and some involvement in community life.

Theodore Sizer's *Horace's Compromise: The Dilemma of the American High School* was the first in a series of reports being sponsored by the National Association of Secondary School Principals and the Commission on Educational Issues of the National Association of Independent Schools. The volume presents Sizer's observations of a number of American high schools made over a two-year period during which he visited mainly social studies and biology classes. He also attempted to detect the ambience of the schools he observed and how it either furthered or impeded the schools' principal obligation to promote significant learning. The volume is another global study of schooling, although Sizer is especially concerned to assess the effects of schooling on the fundamental activity of teaching.

Horace is Horace Smith, a fictitious composite of the knowledgeable, decent, and dedicated teacher who is forced by the circumstances of schooling and teaching in today's high schools to make a number of compromises which redound well neither to his students, himself, nor to the society his students will enter. Yet the hope for improving schooling and teaching lies mainly with the Horace Smiths and the adolescents they teach, adolescents who, Sizer thinks, deserve better than what they are getting and who are capable of doing more than they are asked.

Of all the reports and studies currently under discussion, Sizer's is the most personal and humanistic in its concern for the quality of schooling and the lives of adolescents. He views the schools as human institutions in which students are given learners' permits to learn how to learn and to become decent

human beings. Sizer's bugbear are models of school manage-
ment derived from the social sciences rather than from the
humanities. For example, in his opening chapter he writes that
his

> point of view throughout has been primarily that of schoolteacher
> and principal, roles that force on one an intense awareness of the
> frailties and strengths of individual human beings. There is a bias
> here that I recognize—that the craft of teaching is both art and
> science, and that the poetry in learning and teaching is as important
> to promote as the purposeful. Social and behavioral science, usually
> driven by purposeful ends, has dominated the way contemporary
> Americans view and administer their schools. Such science undoubt-
> edly has its contributions, but the humanities' place deserves fresh
> emphasis. We deal with adolescents' hearts as well as brains, with
> human idiosyncrasies as well as their calculable commonalities.

In his last chapter he writes that although Horace Smith and
others like him are important if we are to have better schools,
the climate of these schools will be determined by adolescents
who are respected. We must therefore take adolescents more
seriously—"not out of some resurgence of 1960s' chic," but
"out of simple human courtesy and recognition that adolescents
do have power, power that can be influenced to serve decent
and constructive ends."

Here then is perhaps the best critical response yet to industrial
models of schooling that made educational headlines in the
1970s, conceptions which, if we are to believe Sizer, are suffi-
ciently institutionalized to constitute serious obstacles to
reform and humanistic education. Above all, Sizer is concerned
about a pyramidal system of governance from the top down
that tends toward greater standardization and emphasizes those
aspects of schooling which lend themselves to efficient con-
trol and measurement. A larger scale of operations, orderly pre-
dictability, high degrees of specificity, quantitative reporting
and evaluation, resistance to significant change, and the stifling
of local initiative are some of the consequences of such a sys-
tem. The system, moreover, generally favors those in the top
positions of an interlocking complex of school administrators
and the institutions that prepare and certify them—a point,
however, that is not emphasized as heavily as it was, say, in
Arthur Bestor's critique of the educational establishment of

yesteryear. The fact of the matter, says Sizer, is that the system is getting in the way of genuine teaching and learning, the schools' fundamental enterprise.

Sizer's observations are reminiscent of John Kenneth Galbraith's analysis of the new industrial state in which the principal decision makers of large corporations act to preserve the system and their place in it regardless of the system's harmful effects on the rest of society. However overdrawn the comparison, there is no doubt that career incentives are greater at the upper administration levels of the educational system than they are in teaching and that administrators prefer to keep matters that way. This is why teachers must leave the classroom if they are to improve their economic condition. This prompts the conclusion that there surely is something seriously defective in a system that undervalues what is most central to it, teaching. Since Sizer's findings about the structure, substance, and ambience of high schools are similar to Goodlad's and Boyer's, we may move to his remedy.

Influenced by his own background and interests, which include history, the deanship of the Harvard graduate college of education, and the principalship of Phillips Academy, a prestigious private school, Sizer is reluctant to limit the freedom of parents and students to choose the kind of educational program and the school they prefer. Society, he thinks, can justifiably require mastery of only a minimum number of basic skills in the three R's and civics. He even goes so far as to say that if mastery of such basic skills and ideas can be demonstrated before high school, students need not attend. The federal government, states, and communities, however, may and should encourage students to pursue further study.

Assuming that basic skills and ideas have been mastered and that students have exercised their option to continue attending high school, what should they study? First of all, schools are to be given greater latitude in determining and designing their programs than in the recommendations of the other studies under discussion. But they should be guided by the motto "less is more." In order to stop the proliferation of subjects and diminish the frenetic quality of the school day, Sizer would reduce the curriculum to four basic areas of study, each of which would be assigned a significant bloc of time and would allow

some choice in the methods for moving students through it. In many instances, this would mean foregoing the conventional fifty-minute period for longer periods of instruction and learning. The four basic areas of study, which could be large departments, are inquiry and expression, mathematics and science, literature and the arts, and philosophy and history.

By "expression" Sizer means not just written communication, which is basic and fundamental, but also visual communication that includes gesture, physical nuance, and tone. Expression also encompasses literature and the arts, and they are sufficiently different to be a separate area of study. Unlike other writers, Sizer thinks it is wasteful to separate the teaching of literature from the other arts inasmuch as "aesthetic expression and learning from others' attempts to find meaning are of a piece." Apart, however, from brief references to classes in Shakespeare's *Romeo and Juliet* and Graham Green's short story "The Destructors," Sizer does not describe the teaching of the arts in the schools he studied.

Anticipating questions, Sizer says tracking will not be a problem because individual interests and differential rates of learning can be accommodated in the areas and blocs of time alloted. Significant physical and career education, though not of the conventional sort, could also be provided in such blocs. And it is more important, Sizer thinks, to overcome ethnocentrism than to learn a foreign language for which one has no use. Standards would be maintained with a combination of demonstrated performance in each of the four basic areas and external testing.

One final observation. Sizer's volume belongs to a small genre of educational writing sometimes called humanistic or qualitative evaluation in contrast to quantitative assessment. The genre is rapidly becoming professionalized and thus is in danger of overextending itself. Ideally, humanistic evaluation requires considerable finesse and consists of an artful blending of first-hand observation, empirical data, and personal judgment. Up to now the results have ranged from interesting collages (sometimes mélanges) of different kinds of information, verbal and visual, to mawkishly immature attempts at characterization and excessively precious literary portraits. Sizer refers to his own effort as a word portrait somewhere between journalism and nonfiction fiction that attempts to provide readers

with a feel of a school. He acknowledges such portraits inevitably distort and reveal a point of view. He is correct, of course, but as a sample of the genre in question Sizer seems to have struck a good balance between description, interpretation, and evaluation, his miniportraits only occasionally being awkward. In contrast, say, to Sara Lawrence Lightfoot's style in *The Good High School*, another example of the genre, Sizer's is not overly self-conscious and thus does not distract the reader from the main line of discussion. Sizer's volume also proves what should have been obvious: humanistic evaluation is not for novices, yet novices have been let loose on the schools to practice it.

The character and components of an excellence curriculum should not be tailored solely to the needs of college-bound youth. Only if recommendations for college preparation are consistent with an excellence curriculum for all students do they warrant attention. In this connection, the College Board's publication *Academic Preparation in the Arts* is relevant to thinking about an excellence curriculum in art education at the secondary level.

Academic Preparation in the Arts, a College Board follow-up report to its *Academic Preparation for College*, goes farther than its predecessor in detailing the goals, scope, and sequence of secondary art education. Its central assumption is that art is a basic subject that has distinct goals and outcomes the attainment of which concomitantly contributes to the development of general academic competencies (such as speaking and listening, reading, studying, reasoning, and observing). While the report is unnecessarily hesitant in stating its case—there is characteristic deference made to alternative ways of achieving objectives—the principal writers, Dennis Wolf and Thomas Wolf, are persuaded that the teaching of art as a distinct subject should impart three kinds of knowledge (understood as abilities)—knowledge not only of how to produce or perform works of art, but also knowledge of how to analyze, interpret, and evaluate them, and knowledge of how to understand them culturally and historically.

Although there is no discussion of a comprehensive plan for, say, six years of secondary schooling of the sort set out in chapter 3 of this essay, a description of several existing courses indi-

cates how the authors think the abilities in question can be developed. The model excellence curriculum discussed in this essay assumes the importance of the abilities described by the College Board report and goes on to detail the scope and sequence of a curriculum designed to attain them.

Otherwise, *Academic Preparation in the Arts* is full of good, common sense and comments on a number of issues that have exercised critics of art education policy over the past two decades. For example, the authors understand the value of intensive, carefully designed instruction in the arts, realizing that lasting understanding and enjoyment are the consequence of much more than mere exposure. They further realize, quite untypically, that the study of the arts helps to transcend one's immediate culture and thus inhibits the blindness inherent in ethnocentrism. Common sense is further evident in the realization that the use of the arts to further the objectives of a history or social studies unit is no substitute for the deliberate cultivation of aesthetic skills. The small contribution to the long-range objectives of aesthetic learning made by artist residencies is also understood. The lessons of the immediate past, in other words, have been well learned.

One cavils only at the report's lack of critical decisiveness and its willingness to entertain a range of alternative ways to achieve its objectives. Critical decisiveness, after all, is not necessarily an expression of a doctrinaire attitude, or of dogmatism; it derives from a belief that doing things certain ways is likely to prove more effective than others. The case for an excellence curriculum presented in this essay, for example, does not limply assert that the model is merely one among many; it stands by *this* model. Debate and discussion in general should center on well-reasoned and sufficiently detailed recommendations, not just on statements of general aims and skills. E. D. Hirsch, Jr., in his discussion of the idea of cultural literacy, has described the limitations of this latter way of educational thinking. Still, *Academic Preparation in the Arts* deserves mention here for its potential usefulness in designing an excellence curriculum.

Before continuing, it is perhaps worth noting that educators of a predominately Left political persuasion tend to see the reports under discussion in this essay as furthering the process of cultural reproduction. By this they mean the effort on the

part of educational reformers to reproduce through the schools the dominant and, in the minds of these critics, the questionable values and power relations of a capitalistic system. That may be true of some of the more technical reports not discussed in this essay, but it is difficult to square this charge with the writings of Adler, Boyer, Goodlad, and Sizer, as well with the following writers who, because their work was not sponsored by prestigious organizations, are less well known than they should be.

Certainly the charge of cultural reproduction cannot be leveled at Harry S. Broudy's *Truth and Credibility: The Citizen's Dilemma*, a volume that contains a persuasive argument for the arts and humanities as part of a program of general education. Given the grounding of his study of the problems of society and education in a cogent social analysis, a knowledge of classical and modern philosophy, and a good understanding of the real world of the public schools, Broudy's is the most convincing case for equity and excellence yet made. Important for purposes of this essay is his reliance on the arts and humanities to help remoralize a society that has been induced by technological and information overload, specialism, and the pitfalls of planning to abandon moral and aesthetic attitudes in favor of economic and technical solutions to problems.

Broudy resorts to the arts and humanities because he believes them to be important resources for building in individuals what he calls a sense of warranted commitment. This contrasts to the warranted assertions of scientific inquiry. By presenting dramatic value images of life's various aspects and possible predicaments, the products of the arts and humanities function as models of human excellence whose persuasiveness is enhanced by their aesthetic appeal. There are risks in this persuasiveness, however, for aesthetic appeal might also encourage the imitation of the unworthy. This is why Broudy cautions that value exemplars must be carefully selected and why, in the second chapter of this essay, a "safety valve" was recommended to insure that the contents of art are occasionally subjected to critical reflection.

Broudy's emphasis on the educative value of classics and exemplars assumes the relevance of classical humanism to the contemporary era. In making the arts and humanities the

central loci of personal and existential truth, however, he also reveals his long-standing interest in the modern philosophy of existentialism. Indeed, one of the several merits of his work is the attempt to synthesize tenets of classical humanism, existentialism, and pragmatism. In *Truth and Credibility*, in other words, Broudy's debts are not just to Aristotle but also to Kierkegaard and Dewey.

Broudy answers affirmatively the question that Robert Penn Warren asked in his Jefferson lecture—whether making our world more humanely habitable involves acceptance not only of the knowledge which comes from the sciences but also that which comes from the feelingful acts of the imagination characteristically found in the arts and literature. One of the problems with modern society, says Broudy, is that humanists, journalists, and other professionals who have the power significantly to influence thought and action have become part of the problem of contemporary life. It is as if Broudy borrowed his words directly from Saul Bellow's principal character in *The Dean's December*, who bitterly complained that journalists in particular fail "to deal with the moral, emotional, imaginative life, in short, the *true* life of human beings, and that their great power prevents people from having access to this true life." Not content to condemn journalists, Bellow's character went on to indict academics, corporate functionaries, lawyers, and many others who are also "incapable of clarifying our principal problems and of depicting democracy to itself in this time of agonized struggle."

Broudy's response to the dilemma of the citizen, who has the double burden of trying to decide not only what but also whom to believe, is a reaffirmation of traditional democratic ideals embodied in the American Creed, the acceptance of the methods of science for producing warranted assertions about matters of fact, and a common, general education that stresses the importance of an artful balance of the various realms of intellectual, moral, and aesthetic value. A reintegration of values can avoid the reductionism that occurs when one value realm becomes dominant in a society—for example, when a society no longer values works of art for the meanings they convey or the aesthetic pleasure they afford but only for their economic value. Reductionism of any kind makes it impossible to maximize the

diverse values of human existence, and the good life suffers as a consequence.

The path to the remoralization of society is opened not by the rejection of science but by the recognition of what the sciences cannot do and what the arts and humanities can. The task for designers of a credibility curriculum is to effect a balance among the different realms of value, which today implies a reinvigoration of the arts and humanities to offset the emphasis on scientific and technological subjects. Such a curriculum would consist of genuinely liberal studies that would serve the end of self-cultivation rather than the objectives of special interest groups and social expediency. Intellectually, a credibility curriculum is charged with building the interpretive frameworks for understanding that citizens will need to act rationally in behalf of the common good and to live well. Morally, it is justified by its commitment to democratic values and the criteria of a just society. Aesthetically, such a curriculum avails itself of the products of the arts and humanities for the satisfaction they provide and as sources of existential truth.

More specifically, Broudy's curriculum of liberal studies is grounded in a conception of four uses of knowledge: replicative, associative, interpretive, and applicative. The interpretive and associative uses are especially pertinent to building a sense of warranted commitment. Extrapolating from the work of Michael Polanyi, Broudy believes that learning mastered explicitly during the school years functions tacitly later in life when individuals encounter a broad range of situations, including those that involve the understanding and appreciating of works of art.

> The disciplines studied explicitly in school become resources used tacitly in life; their details are forgotten, leaving frames or lenses or stencils of interpretation, both of fact and value. Perspective and context are the functional residues of general education. We understand with them, even though we are not attending to them. I believe that a convincing case can be made for the functionality of formal course work in the associative and interpretive uses of knowledge, even though the context of the formal courses cannot be recalled on cue.

The suggestion in chapter 3 that the task of an excellence curriculum is to help the young first to build and then to think

with a sense of an artworld drew not only on recent aesthetic writings about the relations of theory and the artworld—for example, Arthur Danto's—but also on Polanyi's and Broudy's notions about tacit knowing and its sources. Although all experience contributes to the building of an individual's store of images and concepts by which experience is felt, understood, and evaluated, Broudy thinks the arts are preeminently suited to develop the associative and interpretive uses of learning.

It is the business of aesthetic education to teach students how to use the resources of the arts. In Broudy's view, aesthetic education has a twofold function: it teaches students how to experience the arts aesthetically for their inherent values and delight, and it contributes to their general imagic-conceptual store, or apperceptive mass, that functions tacitly in interpreting a broad range of situations, including aesthetic ones. For all of the reasons given above, Broudy's credibility curriculum is a far more cogent and substantive analysis of learning and general education than anything found in the current excellence-in-education literature. Broudy's writing also reflects an optimism that individuals can remoralize themselves and society. Given sufficient investments of energy and a wholehearted commitment, he thinks such a curriculum could go a long way toward creating a society that provides maximum opportunities for the realization of value in all the important domains of human life, greater social justice, and more compassion—his three criteria for the good society.

Another indication that the climate of opinion today is favorable to the development of an excellence curriculum for art education is Maxine Greene's chapter "Aesthetic Literacy in General Education" in the 1981 NSSE Yearbook titled *Philosophy and Education*. Greene, who is William F. Russell Professor in the Foundations of Education at Teachers College, Columbia University, cites a number of paradoxes and anomalies in the relations of art, society, and schooling today. Among them are the contrast between the virtual explosion of interest in the arts, including high art, in the culture and their relative neglect in the schools and the disparity between the intensity of people's expressed interest in art and the unenlightened quality of their response to it. The remedy Greene suggests involves helping persons to become aesthetically literate.

By "aesthetic literacy" Greene understands the possession of interpretive skills that enable persons to engage works of art in their full complexity. Central to the development of such literacy is instruction in the nature of and capacity to have aesthetic experiences of practically anything, but mainly outstanding works of art. Her recommendations are accordingly compatible with the excellence curriculum described in chapter 3. Greene writes that whether we understand works of art as symbol systems, provinces of meaning, or privileged objects capable of inducing a certain kind of response, we do well to appreciate the fact that interpretive skills are required to render works of art intelligible. She laments, however, that far too little is done "to empower students to perceive aesthetically, to become discriminating in their encounters with the arts, to develop vocabularies for articulating what such encounters permit them to see or to hear or to feel." The remarks recall the lopsided emphasis on playing and performing Goodlad observed in his study of schooling.

To overcome aesthetic illiteracy Greene recommends a substantial grounding in aesthetics, or philosophy of art, as part of an art teacher's training. This would enable teachers to handle a number of questions that emerge in efforts to engage and understand works of art, questions that involve the definition of art, the nature of aesthetic concepts, troublesome and misleading dichotomies, and so forth. Indeed, seldom has the case for the relevance of aesthetics, aesthetic terminology, and a concept of aesthetic education been made so emphatically. Greene's argument lays to rest any lingering doubts about the importance of aesthetic theory for art education. The idea of aesthetic education in the sense that Greene talks about it has proven its value not only in her work at the Lincoln Center for the Performing Arts in New York City but also in Broudy's comparable efforts at the Los Angeles Music Center and in the use of the SWRL aesthetic education materials in the initial educational efforts of the Getty Center for Education in the Arts.

Despite the increasing acceptance in the literature of art education of the relevance of aesthetics, aesthetic considerations, and aesthetic terminology, it is likely that still more time will be required for its relevance to be appreciated. This is because aesthetics has become institutionalized in departments

of philosophy only during the past forty years or so, while efforts to indicate the uses of aesthetics in thinking about art education date mainly from the last two decades. The point here, however, is Greene's readiness to entertain the importance of the philosophy of art as part of a teacher's preparation. This bodes well for an excellence curriculum, for aesthetics helps students to understand a number of issues about the status, meaning, and value of art.

Initiatives in the Theory of Art Education

Another development that suggests the field of art education may be poised to strive for exccllence is the reconceptualization of the field that has occurred over the past two decades. While, to be sure, the field of art education reflects just about every point of view imaginable (each wave of reform seems to leave some residue), and while earlier views still enjoy considerable influence in the classroom, the theoretical literature has moved away from a conception of art education as a general developmental activity that places psychological and social growth above the mastery of the basic concepts and skills of art to one that stresses precisely such mastery.

It was in the late fifties and early sixties when the field of art education began to think of itself as a discipline that the paradigm (or model or image) of art education began to change from one that emphasized almost solely child art to one that, while not necessarily ruling out creative activities, supplemented them in important ways with the development of perceptual skills, historical understanding, and aesthetic judgment. These new objectives can be subsumed under the general goal of developing an enlightened appreciation of art. Even when the importance of making art objects was retained in redefinitions of the field, it was likely to be valued more for its contribution to an understanding of art itself and its unique effects than for its general developmental or social outcomes. To think of art as a subject important in itself, moreover, meant giving greater attention to the nature of art, the functions it performs, the ways it should be experienced and judged, and so forth. It also necessitated thought about the systematic design and evaluation of curricula. In brief, the reconceptualization of art edu-

cation conveys the message that significant educational value can be realized in perceiving as well as in creating art, or, as one prominent strand of thought during the period put it, in aesthetically experiencing art as well as in making it.

Part of the reconceptualization of the field consisted of criticisms that some educators leveled at certain groups—mainly governmental and philanthropic—which attempted to champion the arts as catalysts for general educational reform, a role the arts were thought to perform best by becoming part and parcel of all school subjects. Critics insisted, however, that such use of the arts is no substitute for formal art instruction as part of a common, general education designed for the citizen as nonspecialist. What recent writings in art education convey, in other words, is that images of the field of art education no longer feature the child-artist or the artist-teacher in the ways they have in the past. The field is increasingly being conceptualized as one in which subject-matter specialists teach an understanding and appreciation of art in ways that will enable students upon leaving school to engage art intelligently. Once again, the image of the student as enlightened appreciator is consistent with the literature, especially insofar as "enlightened" suggests a more rigorous notion of appreciation than previously.

It is convenient to discuss theoretical developments in the literature of art education under the themes of knowledge and value. The first theme, represented by the term knowledge, reflects the importance theorists now attach to content or subject matter in the teaching of art. This emphasis derives from a belief that characteristic ideas, concepts, and principles are involved in developing an educated understanding and appreciation of art; this, in turn, argues for a separate area of instruction in the curriculum. Knowledge and subject matter, moreover, are to be put in the service of securing end states variously called qualitative intelligence, enlightened cherishing, aesthetic literacy (including visual aesthetic literacy), and reflective percipience. All refer to a set of special competencies, skills, or dispositions involved in educated commerce with art. Finally, the curriculum reform movement of the sixties, with its emphasis on teaching the basic ideas of a subject, stimulated theorists to inquire into the structure of knowledge in art education.

Jerome Bruner's *The Process of Education* thus influenced thinking about the teaching of art the way it did everything else in education.

It is one thing, however, to say that the purpose of art education is to develop excellences of mind called qualitative thinking or aesthetic literacy and something else to describe the benefits to the individual and society that percipience in matters of art confers. In the estimation of numerous writers, and of this essay, the value of art resides in its capacity to energize perception and expand the scope of awareness in worthwhile ways. The term "aesthetic experience" is often used to characterize the kind of experience art typically affords. But terminology is less important than the awareness of a difference between having knowledge *about* art and personally *experiencing* its presence and power. Perhaps no one has marked this distinction better than Frank Sibley. It does no good, he says, merely to be *told* that a work of art has a certain character or meaning, one has to see and feel for oneself its qualities and import; otherwise appreciation is not possible.

A number of writers have contributed substantively to the reconceptualization of the field of art education. Although it cannot be assumed that they would all endorse this essay, either in its general themes or terminology, they have helped to establish its theoretical position for pursuing excellence in art education. For example, philosophers of art such as Thomas Munro, L. A. Reid, Iredell Jenkins, D. W. Gotshalk, Virgil C. Aldrich, Donald Crawford, Monroe C. Beardsley, Nelson Goodman, Eugene F. Kaelin, Francis Sparshott, and Harold Osborne have all written on the relevance of philosophy of art to the problem areas of art education, often in cooperation with or at the invitation of those in the field of art education. Philosophers of education such as Nathaniel Champlin, Francis Villemain, Harry S. Broudy, Philip H. Phenix, and Maxine Greene have stressed either the importance of qualitative thinking, enlightened cherishing, aesthetic meaning, or aesthetic literacy. Theorists of art education such as Manuel Barkan, Vincent Lanier, Elliot W. Eisner, David W. Ecker, Edmund B. Feldman, Laura Chapman, Stanley S. Madeja, Gilbert Clark, Michael Day, and W. Dwaine Greer have stressed one or more of the following themes: the teaching of art as a subject

important in its own right; the structure of knowledge in art education; art education as a discipline; the cognitive character of artistic creation and appreciation; and the value to art education of the disciplines of artistic creation, aesthetics, art history, and art criticism.

A number of other art educators, for example, Edmund B. Feldman, Gene A. Mittler, Nancy MacGregor, Robert Clements, and George Geahigan have contributed to an understanding of the nature of art criticism and the teaching of critical skills. Curriculum specialists such as Eisner, Chapman, Ronald Silverman, and Arthur Efland have thought systematically about curriculum design and implementation and have shown how curriculum design in art education may proceed. Research scholars such as Howard Gardner, David Perkins, and Michael S. Parsons have provided insights into the nature of aesthetic development and a number of other skills involved in our experience of art. Although less has been done to indicate the relevance of art history to art education, the writings of Mary Erickson, Michael McCarthy, Marcia Pointon, and Paul Brazier come to mind. Of course, some writers' interests are catholic and overlap several domains of art education. Finally, the major textbooks to appear during the past two decades—for example, those by Feldman, Eisner, and Chapman—all acknowledge the importance not only of the creative aspect of art education, but also of its philosophical, historical, and critical dimensions.

Over the past twenty or thirty years, then, a significant amount of theorizing in the field of art education has moved away from a conception of art education that does not necessarily stress the study of art as a subject to a subject-centered conception that for the most part does. This trend is discernible not only in the standard textbook and journal literature but perhaps even more significantly in the commission reports, publications, and policy statements of the National Art Education Association, the most recent of which is the Association's pamphlet *Quality Art Education: An Interpretation.*

It is worth remarking that the literature just mentioned is impressive for its intellectual substance and commitment to the value of art and its role in human existence. Those who think art educators are incapable of seriously addressing the problems of art education are advised to sample what the field's

leading theorists have to say on the topic. To such writers, art is not merely a form of indulgent self-expression and mindless play nor are art education classes places from which thinking absents itself. Rather art is construed as a demanding subject in which understanding and enjoyment derive from the disciplined mastery of the concepts and skills involved in making and appreciating works of art. This literature also contains a wealth of suggestion for designing, implementing, and evaluating curricula. With the call for excellence being heard once again, the field of art education is prepared to respond; or, better, the field has for some time been asserting leadership in the effort to achieve more substance and quality in the teaching of art in the schools. Unfortunately, few outside the field read or care about this literature and thus old stereotypes continue to exert influence.

What also emerges from this literature is the acceptance of aesthetic literacy, or some comparable notion, as the goal of art education, where aesthetic literacy refers to percipience or finesse in matters of understanding art, just as, in a comparable way, scientific literacy implies skill in understanding scientific phenomena. But before aesthetic literacy could become a goal of art education, before, that is, art education could take seriously the business of perceiving, interpreting, and judging works of art, art itself had to be appreciated for its own values; it had to be valued for those respects in which works of art are most characteristically admired. This task has been accomplished, and the next one is to insure that the excellences of mind implied by aesthetic literacy become the possession of the large majority of people.

Initiatives for the Future

Initiatives to improve the quality of art education come from several sources, not only from the profession of art education but also from the public and private sectors. In speaking of the latter, the government, foundations, and similar agencies come to mind. A few words of caution are in order about the activities and programs of such groups. Nothing is perhaps less certain than what the policy of a public or private agency will be from one budget allocation to the next. This is why the profession of

art education must be wary of taking leads from external organizations. Their cultural and educational officials are literally here today and gone tomorrow and they understandably have their own career goals to worry about. In recent years we have seen the emergence and demise of the JDR 3rd Fund and its educational activities in the arts, the arts and humanities branch of the (now) Department of Education, the CEMREL laboratory and its aesthetic education program, the SWRL laboratory program in aesthetic education, the position of arts and humanities adviser in the National Institute of Education, and many of the ventures associated with these programs and positions. Only the profession of art education itself has a persistent, long-term commitment to maintaining and improving the quality of art instruction in the schools. In this respect, we should heed the maxim about looking gift horses in the mouth. And it is a good question whether external agencies have actually done more harm than good in the field of art education, not only with regard to some of the ideas they have promoted (and several of these have definitely been inimical to the best interests of art and art education), but also with regard to the dissension that results when individuals and groups vie for approving nods from funding agencies. With such reservations duly noted, the following initiatives are either consistent with the spirit and theme of this essay or hold promise for substantially improving art education.

After the demise of several public and private agencies involved with educational activities in the arts over the past several years, only one effort has emerged that deserves prominent mention here: the programs of the Getty Center for Education in the Arts, an operating entity of the J. Paul Getty Trust. Although the Center's major emphasis has been on the improvement of elementary art education, the Center's outlook is quite consistent with ideas that could be implemented at the secondary level. Indeed, given the Trust's significant investment in humanistic and art-historical studies, it is reasonable to assume that the Center will eventually address the problem of secondary art education. If it doesn't, a major opportunity will have been lost. The Center's interests in case studies of schools, museum education, and the making of art films for young people will be bypassed here in favor of a few remarks about its

program to provide in-service education to teams of elementary principals and general classroom teachers from the Los Angeles County School District.

The Center's in-service program holds promise for improving the substance of art education because it treats the study of the visual arts as "discipline-based," that is, as being grounded in a number of disciplines—e.g., art history, aesthetics, art criticism, and artistic creation—which are relevant to an understanding and appreciation of art. In contrast to some previous ventures on the part of private or external organizations, the Center has wisely foresworn the evangelical rhetoric of innovation. And instead of bypassing the educational profession, it has prudently decided to take its leads from some of the best thinking in the field. It has also involved a significant number of the field's members as consultants and participants in its various activities. Most importantly, it is serious about art and art education.

A sense of the Center's attitude is found in Leilani Lattin Duke's remarks in "Striving for Excellence in Art Education." Duke, the current director of the Center, writes that "the goal of education in the arts should be to foster the learning of the higher order intellectual skills through presenting arts instruction as a compound discipline. Such an integrated approach includes (a) aesthetic perception, (b) productive or performing skills, (c) arts criticism, and (d) art history." The higher intellectual skills in question may be assumed to be those involved in creating, appreciating, and judging works of art. This is what the Center's educational activities are stressing at the current time. To be sure, it is not always quite clear just how the various components of the compound discipline in question are ultimately to be related, or what their relative proportions will be, or whether there is a special set of dispositions the various disciplines in concert are supposed to fashion. Indeed, it is the policy of the Center to encourage discussions of these questions. Two Center-sponsored interpretations of discipline-based art education, one by Elliot Eisner and the other by Gilbert Clark, Michael Day, and Dwaine Greer, suggest some of the possibilities, both of which are compatible with the aims of an excellence curriculum.

The new educational policy of the National Endowment for the Arts also warrants attention for the greater emphasis it now gives to historical, philosophical, and critical studies of the arts. By supplementing its artists residency programs with commitments to conventional curriculum planning and assessment, the Endowment is in effect saying that pedagogical value resides not only in creative and performing activities but also in critical understanding and appreciation. The new policy thus has potential for contributing to the kind of excellence curriculum sketched in this essay. The test of the policy will be the extent to which the Agency's budget reflects a serious commitment to curriculum planning, design, and evaluation.

Questions have been raised about the implementation of the policy. The Endowment is committed to working with state art agencies, but it is not apparent that such agencies can accomplish the task. Such questions notwithstanding, the new policy embodies a significant change of attitude toward the educational establishment; instead of being ill-disposed toward it, it now seeks its cooperation. The Endowment, however, might well be creating an identity problem for itself, for the more it talks about aesthetics, art history, and art criticism, the more it sounds like the Humanities Endowment.

Yet another educational venture that deserves a mention is the five-year program of the Rockefeller Brothers Fund that awarded gifts of $10,000 to ten exemplary school art programs during each year of the program. The program exemplified the belief that excellence should be identified and rewarded and thus is compatible with the spirit and substance of this essay. But upon examination of the criteria schools were instructed to use in applying for the awards, it is discovered that the Fund's program in effect reinforces the current emphasis on productive and performing activities in the schools and is apparently unconcerned about the condition of arts instruction that Goodlad discovered.

One does not want to be unduly skeptical about a program whose stated aim was to reward excellence, even if in today's educational market $10,000 cannot buy too much; obviously, symbolic value counts for more than the actual amount of money. And until an objective evaluation of award recipients proves otherwise, one may assume that what quality there is in

arts education programs has been identified. It is interesting to note that this is not the way the Getty Center went about things. The Center started with a definite conception of an art education program, and, with the assistance of the Rand Corporation and a team of educators, searched for exemplifications of it but was hard put to find a baker's dozen.

There are doubtless other public and private agencies whose efforts are compatible with the goals of an excellence curriculum, yet the Getty Center and the Arts Endowment seem to be the major initiatives at the moment. An organization like the Alliance for Arts in Education lobbies effectively for arts education legislation and thus performs an important function, but such activities fall outside the major concerns of this essay.

Moving toward the Future

As this essay indicates, education in this country is the subject of intensive discussion. It is crucial that the arts education organizations participate in this discussion and assert requisite leadership. This means addressing difficult questions and facing up to certain realities, a prospect that many of those comfortably placed in the arts education establishment may not relish. It is clear, however, that if the field of arts education does not reform itself, the teaching of the arts in the schools will have an uncertain future and will fail to become a new basic subject of general education.

One of the problems of art education today is the low esteem suffered by colleges of education and departments of art education and those who staff them, a situation that seems to be getting worse. The result is that students are seeking careers in other fields and the budgets and services of art education departments are suffering reductions. To compensate, many departments of art education are mounting ambitious recruiting programs to attract minority and foreign students. Another response is the tendency of members of art education faculties to seek security in administrative positions, to take a second job, or to cultivate their private gardens as best they can. Some are simply awaiting retirement or retiring early.

Exacerbating the problems of arts education is the proclivity of the art, music, literature, theater, dance, and film associa-

tions to go their separate ways. Just as practically all the recent studies of schooling conclude that the structure of the system is getting in the way of learning, so the splintering of arts education into separate specialities is getting in the way of developing a significant arts requirement for the schools. Arts education must therefore undergo change if visual art is to have any chance of becoming a new basic subject. A major reconstruction of arts education requires the following.

The field of arts education must first of all define its mission from the perspective of a general, humanistic education that emphasizes the theme of excellence and access to excellence for all. The basic right of all students is a right to the best, nothing less. This implies an essentially academic conception of the arts as a subject of schooling. Rather than accommodating momentary fashions or the demands of special interest groups, the field of arts education must instead take its cues from the intellectual demands of its subject and the nature of aesthetic learning. A corollary is that teacher preparation programs should stress significant work in the history and theory of the arts, or the humanities generally, as well as in educational theory. What future teachers need is a combination of subject-matter mastery and pedagogical finesse. The latter involves an understanding of what may be called educational epistemology, which is merely a technical term for the study of what is involved in coming to learn and know something. This may sound unremarkable until one realizes that we are only just beginning to understand better the nature of learning and cognitive development.

The present situation suggests further possibilities and alternatives to current ways of training art teachers for the schools. One of the principal messages of this essay is that arts education—not just visual art education but again arts education—should have a much stronger academic character, a view that accords with the literature of the field and recent policy statements of the NAEA. Perhaps, and "perhaps" is used intentionally, teacher preparation programs for secondary art teachers should be housed in and administered by special fine arts education units that would be adjuncts of academic fine arts departments in colleges of liberal arts or schools of humanities. Heading such units could be specialists trained in art as an academic subject who in addition have educational interests.

Academic departments accepting this responsibility would have to devote appropriate resources to the development of fine arts educational units and provide the same kind of career incentives for those staffing them as are available to other faculty members. To reiterate, the preparation of art teachers for the schools is unconscionably fragmented today; it encourages each subfield of arts education to struggle independently. Prospective visual arts teachers are taught in one place, music teachers in another, literature teachers in yet another, and so forth.

Another corollary of such a scheme of teacher preparation is that graduate departments of fine arts would have to assume responsibility for training fine arts educators who would direct the educational programs of undergraduate fine arts departments. It is not unrealistic to assume that some graduate students in a fine arts department could combine, say, an interest in art history or aesthetics with the problems of teaching art to adolescents.

To move the major responsibility for the training of teachers of art for the secondary grades from colleges of education and schools of art to the fine arts departments of colleges of liberal arts and schools of humanities is not a radical idea. It simply endorses the pattern of teacher education in English, science, mathematics, history, and foreign language departments. Such a proposal does not imply a deprofessionalizing of art education. Educational expertise in teaching and learning and curriculum design and evaluation would still be required, as would competence in relevant kinds of research. Nor would it eliminate practice teaching or internship and clinical experiences. Were new divisions of fine arts education to be established in academic departments, at least four things could happen: more academically qualified students would be attracted to the teaching of art as a career; arts education in both the schools and teacher preparation programs would become more coherent; art education would evolve into a more educationally defensible subject; and aesthetic learning in the schools would benefit.

What is being suggested, once again for purposes of discussion, is a new pattern and institutional setting for training teachers of art for the secondary grades. It may be assumed that colleges of education will continue to train elementary school

teachers and perform other important educational functions. This essay does not recommend the closing of colleges of education.

This recommendation probably will not appeal to some in the arts education professions. But we are not talking about a system of teacher preparation and arts education in the schools that continues to benefit those comfortably ensconced in an arts-educational establishment, or one that insures no feelings will be hurt, but rather one that has the potential to improve the quality of learning about the arts in the schools. It is unlikely, however, that anyone in the profession of arts education today would suffer appreciably if the field changed the way it trained teachers. We are not talking about radical revolution, but a gradual, long-term transformation. The period betweeen now and the year 2000 might be a transition period for debate, study, and trial ventures. A number of new departments and programs might be in place shortly thereafter and eventually secondary art education would have a new face. Some readers of these pages would not be around to see the effects of such a transformation. Still, there can be satisfaction in pioneering something different even if the task of completing it must fall to a new generation.

One thing is obviously clear. The field of art education needs strong leadership. It is less a field or a profession than a collection of individuals who pursue their own interests. To use Boyer's expression, it is largely adrift. To be sure, responsibility for the state of art education does not rest entirely with art educators; they must often contend with a hostile and indifferent school environment. And in an age of science and technology the arts will always have a difficult time receiving recognition. This essay, however, is at least one sign that the profession of art education is willing to take thought and seriously address some basic problems. It is important that the current moment, which is conducive to change, not be lost; otherwise it is doubtful that art education will ever become a new basic subject in a program of general education. With foresight and the recognition of the need to do things differently, it could become one.

Postscript, 1987

Two reports which have appeared since the first printing of this essay warrant a few remarks: the Carnegie Foundation report *A Nation Prepared: Teachers for the 21st Century*; and *Tomorrow's Teachers: A Report of the Holmes Group*, released by a consortium of educational institutions. Both were published in the spring of 1986.

While *A Nation Prepared* unequivocally states that its principal concern is to make the economy of this nation more competitive in the world today, it shares several features in common with *Tomorrow's Teachers*, which simply expresses the determination of a group of college of education administrators to improve their teacher education programs. Both reports are notable for the discussion they have generated about the need to improve not only teacher education but learning in higher education generally, for the fate of teacher preparation is closely tied to the latter. For example, the reports point out that not only colleges of education are responsible for the quality of instruction in the schools today but also colleges of liberal arts and sciences in which prospective teachers, at least secondary teachers, receive the major part of their instruction.

What is most relevant in these reports so far as the discussion of teacher preparation in this essay is concerned is their recommendation that undergraduate majors in education, both elementary and secondary, be discontinued in favor of a strong liberal arts program that requires an understanding of a range of basic subjects and skills. Professional preparation in education would be deferred until the graduate years and would consist of course work in educational theory and practice teaching. Such programs would prepare teachers for what in the terminology of the Holmes report would ultimately be a career ladder having three rungs: instructor, professional teacher, and career professional. The basic reason for revamping teacher education is quite simple; practically no one in higher education is doing a good job in preparing professionals for the field of education. Once more, the quality of liberal arts instruction that prospective teachers receive is as much of a concern as the instruction they receive in colleges of education.

How does the recommendation to discontinue undergraduate majors in education square with the suggestions for reforming

the preparation of art teachers in this essay? It is essentially the same. Recall it has been pointed out that inasmuch as teachers of art are increasingly being asked to undertake historical, critical, and philosophical studies of the arts, they are in effect being asked to teach their subject from a humanities point of view. The question was next raised whether teachers of art should be prepared in academic fine arts departments of colleges of liberal arts (or schools of humanities) which are better equipped to convey the necessary knowledge and skills. Again, this is the dominant pattern for preparing teachers of other subjects for the secondary level. Were this to happen, it could be anticipated that more highly qualified students could be attracted to the teaching of art as a career. In short, the suggestions made in this essay are quite congruent with those made in the Carnegie and Holmes reports.

The Carnegie report goes further than the Holmes report in drawing attention to promising programs. And since the fading of the elementary art education specialist is of some concern to the field of art education, it should be pointed out that both reports believe that elementary teachers should be as rigorously trained in their subjects as secondary teachers. The Carnegie report states that this implies a reorganization of elementary schools to make elementary teachers responsible for fewer subjects. This does not imply removing art from the curriculum; if anything, it implies more art specialists.

In its discussion of teacher preparation, this essay did not recommend the elimination of undergraduate majors in art education, but the discussion in effect amounted to the same thing. In truth, this essay goes beyond the Carnegie and Holmes reports in suggesting how academic and pedagogical interests might be combined in an academic fine arts department. In this respect, it was suggested that there might be a role for a fine arts educational specialist who could advise students looking forward to a career in the teaching of art at the secondary level. One thing seems apparent: given the interest in reforming teacher education, the preparation of teachers of arts for the schools is likely to undergo major changes in the years ahead.

Notes

1 Excellence, the Continuing Ideal

The opening quotation is from Moses Hadas, *The Greek Ideal and Its Survival* (New York: Harper Colophon Books, 1966), p. 13.

p. 1 "The theme is still excellence and equity."

Any brief bibliography of works devoted more or less explicitly to discussions of excellence from the sixties to the present should include the following: Jerome Bruner, *The Process of Education* (1960), with new preface (Cambridge: Harvard University Press, 1977); John W. Gardner, *Excellence: Can We Be Equal and Excellent Too?* (1961), rev. ed. (New York: W. W. Norton, 1984); Stephen R. Graubard and Gerald Holton, eds., *Excellence and Leadership in a Democracy* (New York: Columbia University Press, 1962); Harry S. Broudy, B. Othanel Smith, and Joe R. Burnett, *Democracy and Excellence in American Secondary Education* (Chicago: Rand McNally & Co., 1964; reprint edition, Huntington, New York: Robert E. Krieger, 1978); Thomas J. Peters and Robert W. Waterman, Sr., *In Search of Excellence* (New York: Harper & Row, 1982); Stephen Miller, *Excellence & Equity: The National Endowment for the Humanities* (Lexington: University of Kentucky Press, 1984); Chester E. Finn, Jr., Diane Ravitch, and Robert T. Faucher, *Against Mediocrity: The Humanities in America's High Schools* (New York: Holmes R. Myer, 1984); Mary Ann Raywid, Charles A. Tesconi, Jr., and Donald R. Warren, *Pride and Promise: Schools of Excellence for All the People* (Westbury, N.Y.: American Educational Studies Association, 1984).

p. 4 "The ancient Greeks first prized. . ."

See Werner Jaeger, *Paideia: The Ideals of Greek Culture*, trans. Gilbert Highet, 3 vols. (New York: Oxford University Press, 1939-1945); and Hadas, *The Greek Ideal and Its Survival*, op. cit.

p. 5 "Excellences of mind, moreover, may be understood as dispositions. . ."

In this respect, see William Frankena, *Three Historical Philosophies of Education: Aristotle, Kant, Dewey* (Glenview, Illinois: Scott, Foresman and Co., 1965), esp. chap. 1. Also his "The Concept of Education Today," in *Educational Judgments*, ed. James F. Doyle (Boston: Routledge & Kegan Paul, 1973). In the latter, Frankena writes that "what I am suggesting is that education be conceived of as the fostering and acquiring, by

appropriate methods, of desirable dispositions, and that the dispositions that are desirable. . . consist of a mastery of forms of thought and action with their respective standards, together with responsibility and autonomy" (p. 31). Cf. Donald Arnstine, *Philosophy of Education* (New York: Harper & Row, 1967), esp. pp. 31-40.

". . . the cluster of reports and studies in question. . ."

This essay discusses or mentions only a representative sample of recent reports and studies about education: e.g., The National Commission on Excellence in Education, *A Nation at Risk* (Washington, D.C.: GPO, 1983); Mortimer J. Adler, *The Paideia Proposal: An Educational Manifesto* (New York: Macmillan, 1982); Mortimer J. Adler, *Paideia Problems and Possibilities* (New York: Macmillan, 1983); Mortimer J. Adler, ed., *The Paideia Program: An Educational Syllabus* (New York: Macmillan, 1984); Ernest L. Boyer, *High School: A Report on Secondary Education in America* (New York: Harper & Row, 1983); John I. Goodlad, *A Place Called School* (New York: McGraw-Hill, 1984); *Academic Preparation for College* (New York: The College Board, 1983); *Academic Preparation in the Arts* (New York: The College Board, 1985); Theodore R. Sizer, *Horace's Compromise: The Dilemma of the American High School* (Boston: Houghton Mifflin, 1984); and Sara Lawrence Lightfoot, *The Good High School: Portraits of Character and Culture* (New York: Basic Books, 1983), although the latter is mentioned more than discussed.

After *A Nation at Risk*, the various reports and studies might be read in the following order. For a sense of the obdurate realities of schooling, start with Goodlad. Then read Boyer for a more condensed account of the conditions of schooling plus an agenda for reform. On to Sizer for an antidote to the increasing standardization of schooling. And finally to the Adler volumes and the College Board publications. Lightfoot can be read as an example of the developing art of literary portrayals of schools.

p. 6 ". . . the kind of criticism that has often been directed at schools. . ."

For samples of such criticism, see Diane Ravitch, *The Troubled Crusade: American Education, 1945-1980* (New York: Basic Books, 1983), chap. 7.

p. 8 ". . . Paul E. Peterson writes. . ."

See his "Did the Education Commissions Say Anything?" *The Brookings Review* 2, No. 2 (Winter 1983).

p. 9 "We have yet to recover ground lost during that period. . ."

For a critical description of the quality of intellectual life in the sixties, see Ronald Berman, *America in the Sixties: An Intellectual History* (New York: Free Press, 1968).

". . . the best is not too good for Marva Collins's minority children. . ."

For a description of Collins's work and some of the criticism it has received, see Rita Kramer, "Marva Collins and American Public Education,"

The American Spectator 16, No. 4 (April 1983). Kramer writes that Collins's view "that hard work and becoming acquainted with what has stood the test of time in the ongoing dialogue of literature is still the best foundation on which to build thoughtful men and women and responsible citizens is not popular today" (p. 7). The program started by Jesse Jackson is described in a booklet called *Push-Excel* (Chicago: PUSH for Excellence, Inc., n.d.).

p. 11 ". . . serious criticism of education and teacher preparation by educators themselves. . ."

See Harry S. Broudy, *The Real World of the Public Schools* (New York: Harcourt Brace Jovanovich, 1972); and B. Othanel Smith, "Pedagogical Education: How about Reform?" *Phi Delta Kappan* 62, No. 2 (October 1980).

p. 12 ". . . the literary critic Lionel Trilling asked. . ."

See his essay "The Uncertain Future of the Humanistic Educational Ideal," in Lionel Trilling, *The Last Decade: Essays and Reviews, 1965-1975*, ed. Diana Trilling (New York: Harcourt Brace Jovanovich, 1977).

p. 13 ". . . to agree with Aristotle. . ."

The references in question are Aristotle, *Nicomachean Ethics*, Bk X, 7; Goethe, "Travels in Italy," 3 March 1787, *The Complete Works of Goethe*, vol. 4; and Arnold, *Culture & Anarchy* (1869) (New York: Cambridge University Press, 1969), p. 70.

2 Excellence in Art

The opening quotation is from Harold Osborne's *The Art of Appreciation* (New York: Oxford University Press, 1970), pp. 36-37.

p. 15 ". . . into what Ernst Cassirer in his classic. . ."

See his *An Essay on Man* (New Haven: Yale University Press, 1944), p. 68.

Some recent works which stress multiple forms of human comprehension are Philip H. Phenix, *Realms of Meaning* (New York: McGraw-Hill, 1964); Paul H. Hirst, *Knowledge and the Curriculum* (Boston: Routledge & Kegan Paul, 1974); Elliot W. Eisner, *Cognition and Curriculum* (New York: Longman, 1982); Howard Gardner, *Frames of Mind* (New York: Basic Books, 1983); and Louis Arnaud Reid, *Ways of Understanding and Education* (London: Heinemann Educational Books, 1986).

p. 18 ". . . a significant tradition of aesthetic and cultural thought. . ."

The works mentioned are Friedrich Schiller, *Letters on the Aesthetic Education of Man* (1795), trans. R. Snell (New York: Frederick Ungar,

1965). Also the English and German facing edition edited and translated by Elizabeth M. Wilkinson and L. A. Willoughby (New York: Oxford University Press, 1967); Herbert Read, *The Redemption of the Robot* (New York: Simon and Schuster, 1966); and John Dewey, *Art as Experience* (1934) (New York: G. P. Putnam's Sons, 1958). The standard history of aesthetics is Monroe C. Beardsley's *Aesthetics from Classical Greece to the Present* (New York: Macmillan, 1966).

p. 19 ". . . children's interests extend beyond things of their own making. . ."

See Michael S. Parsons, "A Suggestion Concerning the Development of Aesthetic Experience in Children," *Journal of Aesthetics and Art Criticism* 34, No. 3 (Spring 1976); Parsons, Marilyn Johnston, and Robert Durham, "Developmental Stages in Children's Aesthetic Responses, *Journal of Aesthetic Education* 12, No. 1 (January 1978); and David Ecker, "Analyzing Children's Talk about Art," *Journal of Aesthetic Education* 7, No. 1 (January 1973).

p. 20 ". . . we are now beginning to get theories of theories."

In this respect, an indispensable work is Francis Sparshott's *The Theory of the Arts* (Princeton: Princeton University Press, 1962). Sparshott's argument is that anyone wanting to think seriously about the arts must take into account at least four major lines of aesthetic thought: the classical, the expressive, the mystic, and the purist.

p. 21 ". . . of what Abraham Maslow once called. . ."

See his *The Farther Reaches of Human Nature* (New York: Viking Press, 1971).

". . . as Jacques Barzun (following Blaise Pascal) might say. . ."

For a compressed paraphrase of Pascal's distinction between *esprit de finesse* and *esprit de géométrie*, see Barzun's *Clio and the Doctors: Psycho-History, Quanto-History, and History* (Chicago: University of Chicago Press, 1974), pp. 91-92.

p. 22 ". . . at least four different senses of artistic expression. . ."

See John Hospers, *Understanding the Arts* (Englewood Cliffs, N.J.: Prentice-Hall, 1982), chapter 4.

". . . the Russian painter Wassily Kandinsky. . ."

Kandinsky's remarks are quoted by Harold Osborne in his *Abstraction & Artifice in Twentieth-Century Art* (New York: Oxford University Press, 1979), p. 103.

p. 23 ". . . on something so simple as a shallow-bowled spoon."

See L. A. Reid, *A Study in Aesthetics* (New York: Macmillan, 1954), pp. 101-102. Quoted by Lionel Trilling in *A Gathering of Fugitives*, ed. Diana Trilling (New York: Harcourt Brace Jovanovich, 1956), p. 147.

". . . of one of Cézanne's interpretations of Mont Sainte-Victoire. . ."

Meyer Schapiro's description is found in his *Cézanne* (New York: Harry N. Abrams, 1952), p. 74.

p. 24 ". . . the famous mural the *Guernica*. . ."

Kaelin's description is found in his "Aesthetic Education: A Role for Aesthetics Proper," in *Aesthetics and Problems of Education*, ed. R. Smith (Urbana: University of Illinois Press, 1971), p. 154.

". . . the characteristic kind of experience afforded by art. . ."

The discussion follows the writings of Monroe C. Beardsley and Harold Osborne, especially Beardsley's "Aesthetic Experience" in *The Aesthetic Point of View: Selected Essays of Monroe C. Beardsley*, ed. Michael J. Wreen and Donald M. Callen (Ithaca: Cornell University Press, 1982), and Osborne's "Appreciation as Percipience" in his *The Art of Appreciation*, op. cit.

p. 26 ". . . can affect a number of other important human values . . ."

See Beardsley's discussion of the inherent values of aesthetic objects in his *Aesthetics: Problems in the Philosophy of Criticism*, 2nd ed. (Indianapolis: Hackett Pub. Co., 1981), esp. the "Effects of Aesthetic Objects," pp. 573-76.

p. 28 "The aestheticizing of violence in films. . ."

For an insightful discussion of violence in films, see Martin S. Dworkin, "*The Desperate Hours* and the Violent Screen," in *Aesthetics and Criticism in Art Education*, ed. R. A. Smith (Chicago: Rand McNally & Co., 1966).

". . . a covert correlation between aesthetic sensitivity and human cruelty. . ."

See George Steiner's "To Civilize Our Gentlemen," in his *Language and Silence* (New York: Atheneum, 1967). Also his *In Bluebeard's Castle* (New Haven: Yale University Press, 1971).

". . . but, writes Beardsley, . . ."

See his "The Aesthetic Point of View," in *The Aesthetic Point of View*, ed. Wreen and Callen, op. cit., p. 34.

p. 29 ". . . volumes and essays that address the topic of quality in art."

Discussed in this section are the following works: Jakob Rosenberg, *On Quality in Art: Criteria of Excellence, Past and Present* (Princeton: Princeton University Press), 1967; Sherman E. Lee, "Painting," Harold Rosenberg, "Avant-Garde," and Stanley Kauffmann, "Film," all from *Quality: Its Image in the Arts*, ed. Louis Kronenberger (New York: Atheneum, 1969); Kenneth Clark, *What Is a Masterpiece?* (New York: Thames and

Hudson, 1979); Harold Rosenberg, *The De-definition of Art* (New York: Horizon, 1972); and Hilton Kramer, *The Age of the Avant-Garde* (New York: Farrar, Strauss and Giroux, 1973). The Lee essay is reprinted in his *Past, Present, East and West* (New York: George Braziller, 1983).

p. 36 ". . . Francis Sparshott says. . ."

See his "Basic Film Aesthetics," in *Film Theory and Criticism*, 2nd ed., ed. Gerald Mast and Marshall Cohen (New York: Oxford University Press, 1979).

p. 37 ". . . what Beardsley discovered. . ."

See his *Aesthetics: Problems in the Philosophy of Criticism*, op. cit., chap. 10.

"Further insight. . . is provided by Osborne. . ."

See his "Assessment and Stature," *British Journal of Aesthetics* 24, No. 1 (Winter 1984). Osborne draws in part on Anthony Savile's *The Test of Time* (New York: Oxford University Press, 1982), esp. chap. 9.

"Nelson Goodman also believes. . ."

See his *Of Mind and Other Matters* (Cambridge: Harvard University Press, 1984), pp. 179-80. Also *Languages of Art*, 2nd ed. (Indianapolis: Hackett Pub. Co., 1976).

". . . Kenneth Clark's *Landscape into Art*. . ."

Landscape into Art (1949) (Boston: Beacon Press, 1961).

p. 38 ". . . move back and forth between nature and art. . ."

For a comprehensive discussion of aesthetics and the environment, including natural phenomena, see Yrjö Sepänmaa, *The Beauty of Environment* (Helsinki: Suomalainen Tiedeakatemia, 1986).

". . . Virgil C. Aldrich has written. . ."

See his *Philosophy of Art* (Englewood Cliffs, N.J.: Prentice-Hall, 1963), pp. 98-99.

p. 39 ". . . as Hilton Kramer has recently pointed out. . ."

See his "T. J. Clark and the Marxist Critique of Modern Painting," *The New Criterion* 3, No. 7 (March 1985).

". . . not art or aesthetic criticism proper so much as cultural criticism. . ."

See Beardsley, "Art and Its Cultural Context," in *The Aesthetic Point of View*, ed. Wreen and Callen, op. cit., p. 370.

"Sparshott has said. . ."

See his *The Structure of Aesthetics* (Toronto: University of Toronto Press, 1963). Sparshott writes that "what keeps aesthetics alive. . . is chiefly the difficulty of either getting rid of the notion that art has some cognitive task (or that some works in some of the arts perform some special cognitive functions), or stating intelligently what that task could be" (p. 262). Goodman's *Languages of Art* thus helps to keep aesthetics alive.

"Is art primarily cognitive and aesthetic?"

These are the terms in which aesthetic opinion tends to phrase distinctions. After the publication of the taxonomies of educational objectives in the fifties and sixties, however, art educators tended to equate art education with affective education, the implication being that cognitive objectives were less important. The terms cognitive and affective are troublesome, to say the least, and a strong distinction between the cognitive and the affective in our experience of art is ultimately untenable. For a recent criticism of the purported dichotomy, see James Gribble, *Literary Education: A Reevaluation* (New York: Cambridge University Press, 1983), chap. 5.

p. 42 ". . . mainly for understanding and learning or for a fresh experience. . ."

Regarding these options, consider the following:

a. Kenneth Clark, "Art and Society," in *Moments of Vision* (London: John Murray, 1981): "I believe that the majority of people really long to experience that moment of pure, disinterested, non-material satisfaction which causes them to ejaculate the word 'beautiful'; and since this experience can be obtained more reliably through works of art than through any other means, I believe that those of us who try to make works of art more accessible are not wasting our time" (p. 79).

b. Iris Murdoch, *The Fire and the Sun: Why Plato Banished the Artists* (New York: Oxford University Press, 1977): "Art is far and away the most educational thing we have, far more so than its rivals, philosophy and theology and science" (p. 86). She also writes in the same passage that "of course, art has no formal 'social role' and artists ought not to feel that they must 'serve their society.' They will automatically serve it if they attend to truth and try to produce the best art (make the most beautiful things) of which they are capable."

c. William Arrowsmith, "Art and Education," in *The Arts and the Public*, ed. James E. Miller and Paul D. Herring (Chicago: University of Chicago Press, 1967): "From Homer to Greek tragedy to the Roman moralists to Plutarch to the Church fathers to Dante to Montaigne to Bunyan to Emerson, the single most pervasive function of art has been precisely education" (p. 256).

d. Francis Sparshott, *The Theory of the Arts* (Princeton: Princeton University Press, 1982): "People certainly do produce and study works of art as sources of knowledge or understanding or illumination or something of that cognitive sort. . . . It certainly seems strange to say that one goes to an exhibition of a serious artist in search of pleasure—we go to learn, to seek enlightenment" (p. 133).

"... after the recommendation of Morris Weitz..."

In his "The Role of Theory of Aesthetics," published in his anthology *Problems of Art*, 2nd ed. (New York: Macmillan, 1970), Weitz writes that "it behooves us to deal generously with traditional theories of art, and by implication contemporary ones as well, for each, though having limitations, contains serious recommendations to concentrate on certain criteria of excellence in art. In this respect aesthetic theory is far from worthless; indeed it teaches us what to look for in art and how to do it" (p. 180).

3 Excellence in Art Education

The opening quotation is from Harry S. Broudy, *Enlightened Cherishing: An Essay on Aesthetic Education* (Urbana: University of Illinois Press, 1972), pp. 113-14.

p. 43 "... a cognitive revolution in learning theory..."

This revolution can be traced in Robert M. W. Travers, *Essentials of Learning*, 5th ed. (New York: Macmillan, 1982).

"... an energetic literature of educational evaluation..."

Representative works are George W. Willis, ed., *Qualitative Evaluation* (Berkeley: McCutchan, 1978), and Elliot W. Eisner, *The Educational Imagination* (New York: Macmillan, 1979).

p. 44 "In *Pride and Promise*..."

See Mary Ann Raywid, Charles A. Tesconi, Jr., and Donald R. Warren, *Pride and Promise: Schools of Excellence for All the People* (Westbury, N.Y.: American Educational Studies Association, 1984), pp. 13, 22-23.

p. 46 "... one perceives works of art *with* a sense of an artworld."

The notion of an artworld, although taken from Arthur C. Danto's *The Transfiguration of the Commonplace* (Cambridge: Harvard University Press, 1981), is used in a special sense in this essay: it is both that to which students are introduced and that which they consequently come to think with as they encounter new works of art and reexperience familiar ones. In this latter sense it is part of one's apperceptive mass, or, to use Polanyi's terminology, one's store of tacit knowledge.

p. 47 "... Arnold Hauser has remarked..."

See his *Philosophy of Art History* (New York: Alfred A. Knopf, 1959), p. 369.

p. 49 "... the curriculum theory presented in *Democracy and Excellence in American Secondary Education*..."

Op. cit., esp. chaps. 3-4. In addition to *Democracy and Excellence...*, op. cit., see Broudy's *General Education: The Search for a Rationale*

(Bloomington, Ind.. Phi Delta Kappa Foundation, 1974); and "On 'Knowing With,' " *Philosophy of Education*, Proceedings of the Philosophy of Education Society, ed. H. B. Dunkel (Edwardsville, Ill.: Philosophy of Education Society, 1970). His essay "A Common Curriculum in Aesthetics and Fine Arts" appears in *Individual Differences and the Common Curriculum*, ed. Gary D. Fenstermacher and John I. Goodlad, Eighty-second Yearbook of the National Society for the Study of Education, Part I (Chicago: University of Chicago Press, 1983).

". . . the term 'structure of knowledge' . . ."

For a discussion of the number of different meanings the term has 'acquired in curriculum theory, notably since the publication of Bruner's *The Process of Education*, see Arthur R. King, Jr., and John A. Brownell, *The Curriculum and the Disciplines of Knowledge* (New York: John Wiley, 1966).

p. 50 ". . . what Alexander Sesonske calls the aesthetic complex. . ."

See the introduction to his anthology *What Is Art?* (New York: Oxford University Press, 1965). Also see Donald W. Crawford, "Aesthetics in Discipline-based Art Education," *Journal of Aesthetic Education* 21, No. 2 (Summer 1987), a special double issue devoted to discipline-based art education.

". . . of which Paul Ziff says. . ."

See his "The Task of Defining a Work of Art," *The Philosophical Review* 62, No. 1 (January 1953): 60-61.

p. 51 ". . . five seconds in a front of a work of art. . ."

See Francis Sparshott, "Showing and Saying, Looking and Learning: An Outsider's View of Art Museums," *Journal of Aesthetic Education* 19, No. 2 (Summer 1985): 72, a special issue devoted to art museums and education.

". . . concepts and skills involved in creating, confronting, and criticizing art."

The way, for example, Solon Kimball and James E. McClellan, Jr., put it in their characterization of the discipline of aesthetic form in *Education and the New America* (New York: Random House, 1962), pp. 301-302.

pp. 52-53 ". . . if teaching is in any sense an art. . ."

Two modern classics on the art of teaching are Jacques Barzun, *Teacher in America* (1945) (Indianapolis: Liberty Press, 1981); and Gilbert Highet, *The Art of Teaching* (New York: Random House, 1950).

p. 53 ". . . dialogic (or Socratic) teaching methods."

For descriptions of the Socratic method, see Harry S. Broudy and John R. Palmer, *Exemplars of Teaching Method* (Chicago: Rand McNally,

1965), chap. 3; and Mortimer J. Adler et al., *The Paideia Program: An Educational Syllabus*, op. cit.

". . . are sometimes called 'molar' problems. . ."

See Broudy, Smith, and Burnett, *Democracy and Excellence in American Secondary Education*, op. cit., pp. 241-43.

". . . the backdrop of the past. . ."

For some sensible remarks in this respect, see H. B. Redfern, *Questions in Aesthetic Education* (London: Allen & Unwin, 1986), p. 29.

p. 54 "Philanthropy has been defined. . ."

See Jacques Barzun, *The House of Intellect* (New York: Harper & Brothers, 1959), pp. 21-22.

p. 56 ". . . Albert William Levi redefines the traditional liberal arts . . ."

See his *The Humanities Today* (Bloomington: Indiana University Press, 1970).

p. 57 ". . . Harold Rosenberg's essay that asks. . ."

See "Art and Its Double" in his *Artworks and Packages* (New York: Horizon Press, 1969).

"Ronald Berman has examined. . ."

See his *Culture & Politics* (New York: University Press of America, 1984), chap. 11.

"Jane Jacobs wonders. . ."

See her *The Death and Life of Great American Cities* (New York: Random House, 1961), esp. chap. 19.

p. 58 ". . . problems that surface when different kinds of specialists try to work together."

For some observations along these lines, see Hugh G. Petrie, "Do You See What I See? The Epistemology of Interdisciplinary Inquiry," *Journal of Aesthetic Education* 10, No. 1 (January 1976).

p. 59 "Perceptive observers of alternative education. . ."

See Barbara Leondar, "The Arts in Alternative Schools: Some Observations," *Journal of Aesthetic Education* 5, No. 1 (January 1971).

". . . Mary Ann Raywid's characterization of alternative education. . ."

See her "Synthesis of Research on Schools of Choice," *Educational*

Leadership 41, No. 7 (April 1984); and *The Current Status of Schools of Choice in Public Secondary Education* (Hempstead, N.Y.: Project on Alternatives in Education, Hofstra University, 1982). Cf. Dennis P. Doyle and Marsha Levine, "Magnet Schools: Choice and Quality in Public Education," *Phi Delta Kappan* 66, No. 4 (December 1984).

p. 60 "Michael Polanyi has stressed. . ."

See his *The Tacit Dimension* (New York: Doubleday & Co., 1966); and Polanyi and Harry Prosch, *Meaning* (Chicago: University of Chicago Press, 1975). For applications of Polanyi's ideas in education, see Harry S. Broudy, "Tacit Knowing and Aesthetic Education," in *Aesthetic Concepts and Education*, ed. R. A. Smith (Urbana: University of Illinois Press, 1970); "Tacit Knowing as a Rationale for Liberal Education," *Teachers College Record* 80, No. 3 (1979); and *Truth and Credibility: The Citizen's Dilemma* (New York: Longman, 1981), pp. 147-49. A recent work that addresses the question of learning and interpretive frameworks, including a discussion of Polanyi, is R. J. Brownhill, *Education and the Nature of Knowledge* (London: Croom Helm, 1983).

"A neutral example of one kind of concomitant learning is supplied by Cleanth Brooks. . ."

See his "Combined Studies Program: Literary Elements," in *Papers on Educational Reform*, vol. 4 (La Salle, Illinois: Open Court Publishing Co., 1974), p. 51.

"As it is usually discussed today, however, the idea of a hidden curriculum. . ."

For references see William H. Schubert, *Curriculum Books: The First Eighty Years* (Washington, D.C.: University Press of America, 1980).

p. 61 "The aestheticizing of educational evaluation. . ."

For some observations on this tendency, see Ralph A. Smith, *The New Aesthetic Curriculum Theorists and Their Astonishing Ideas* (Vancouver: Centre for the Study of Curriculum and Instruction: University of British Columbia, 1984).

p. 62 ". . . what Jacques Barzun had in mind. . ."

See his "Where the Educational Nonsense Comes From," in *Papers on Educational Reform*, vol. 2 (La Salle, Illinois: Open Court, 1971).

4 The Question of Elitism

The opening quotations are from Sherman E. Lee, *Past, Present, East and West* (New York: George Braziller, 1983), p. 71; and Bernard Malamud, *The Stories of Bernard Malamud* (New York: Farrar, Straus, Giroux, 1983), pp. x-xi.

p. 70 "According to Stuart Hampshire. . ."

See "Private Pleasures and the Public Purse," a review of Janet Mina-han's *The Nationalization of Culture* (New York: New York University Press, 1977), a study of state subsidies to the arts in Great Britian, in the *Times Literary Supplement*, 13 May 1977, 579.

". . . artists also participate in the formation of critical opinion."

For a sample of artists' opinions, see Robert Goldwater and Marco Treves, ed., *Artists on Art*, 3rd ed. (New York: Pantheon Books, 1958).

". . . as Leo Steinberg has pointed out. . ."

Steinberg's remark, "No critic, no outraged bourgeois, match an artist's passion in repudiation," is from his "Contemporary Art and the Plight of Its Public," in *Other Criteria* (New York: Oxford University Press, 1972), p. 4.

". . . the judgments of critical elites. . ."

See Anthony Savile's *The Test of Time* (New York: Oxford University Press, 1982).

p. 71 "It is precisely such gratification that Kenneth Clark had in mind. . ."

See his "Art and Society" in *Moments of Vision*, op. cit., p. 79.

"Nations and cities build and maintain museums. . ."

For remarks on the civic functions of museums, see Albert William Levi, "The Art Museum as an Agency of Culture," and Mark Lilla, "The Museum in the City," *Journal of Aesthetic Education* 19, No. 2 (Summer 1985), a special issue devoted to art museums and education.

". . . elitists. . . traverse cultural spaces and periods."

See Erwin Panofsky, "Style and Medium in the Motion Pictures," in *Film Theory and Criticism*, 2nd ed., ed. Gerald Mast and Marshall Cohen (New York: Oxford University Press, 1979); William Arrowsmith, "Film as Educator," in *Aesthetics and Problems of Education*, ed. R. A. Smith, op. cit.; Meyer Schapiro, *Romanesque Art: Selected Papers* (New York: George Braziller, 1977), and *Modern Art: 19th and 20th Centuries* (New York: George Braziller, 1978); Leo Steinberg, *Jasper Johns* (New York: George Wittenborn, 1963), and *Michelangelo's Last Paintings* (New York: Oxford University Press, 1975); Jacques Barzun, *The Use and Abuse of Art* (Princeton: Princeton University Press, 1974).

p. 72 ". . . proper for tastes to be disputed."

See Monroe C. Beardsley, "Tastes Can Be Disputed," in *Classic Philo-sophical Questions*, 3rd ed., ed. James A. Gould, (Columbus: Charles E. Merrill, 1979).

". . . the cultural heritage is revolutionary as well as conservationist."

See Broudy's *Enlightened Cherishing*, op. cit., pp. 18-19.

"William Faulkner once remarked. . ."

See Philip K. Jason, "The University as Patron of Literature: The Balch Program of Virginia," *Journal of General Education* 34, No. 3 (1983). The quote from Faulkner reads: ". . . maybe when there are fine listeners there will be fine poets again, that maybe the writing that is not too good is not just the writer's fault, it may be because of the environment, a part of which is the general effluvium of the readers, the people who will read it. That does something to the air they all breathe together, that compels the shape of the book" (p. 178).

p. 74 "Kenneth Clark's examination of the art-historical record. . ."

See his observations in "Art and Society," in *Moments of Vision*, op. cit. For a description of the festivities in question, see John Canaday, *Lives of the Painters*, vol. 1 (New York: W. W. Norton, 1969), pp. 15-16. The interest and controversy stirred by the discovery of the so-called Warriors of Riace is reported in the *NY Times*, 12 July 1981, 3.

p. 75 ". . . Nelson Edmonson asks why he, an agnostic. . ."

See his "An Agnostic Response to Christian Art," *Journal of Aesthetic Education* 15, No. 4 (October 1981): 34.

p. 76 ". . . that people should receive the kind of culture they want. . ."

This is the fundamental error of Herbert J. Gans's *Popular Culture and High Culture: An Analysis and Evaluation of Taste* (New York: Basic Books, 1974).

p. 77 "The basic mistake, writes Richard Hoggart. . ."

See "Excellence and Access," in his *An English Temper* (New York: Oxford University Press, 1982), p. 160.

p. 78 ". . . recall Paul Goodman's criticism. . . of youth culture. . ."

See the preface to his *New Reformation* (New York: Random House, 1970).

". . . Chester Finn's rejection. . ."

See his "The Excellence Backlash: Sources of Resistance to Educational Reform," *The American Spectator* 17, No. 9 (September 1984).

". . . Charles Frankel's observations. . ."

See his "The New Egalitarianism and the Old," *Commentary* 56, No. 3 (September 1973): 61. Also his *The Democratic Prospect* (New York: Harper & Row, 1962).

p. 79 "Arthur Schlesinger, Jr., in effect echoes. . ."

See his "The Challenge to Liberalism," in *An Outline of Man's Knowledge of the Modern World*, ed. Lyman Bryson (New York: McGraw-Hill, 1960), p. 473.

". . . the great nineteenth-century cultural critic. . . Matthew Arnold. . ."

See his *Culture & Anarchy*, op. cit., p. 70.

". . . Lawrence A. Cremin, the eminent historian of American education. . . ."

See his *The Genius of American Education* (New York: Random House Vintage Books, 1966).

"Playfulness and piety, however, are the two faces of any kind of intellectual activity. . ."

See Richard Hofstadter's *Anti-intellectualism in American Life*, op. cit., pp. 29-33. At a time when the definition of cultural and educational relations is constrained by narrow political and ideological considerations and their deadly seriousness, it is worth keeping in mind Hofstadter's observation that "if there is anything more dangerous to the life of the mind than having no independent commitment to ideas, it is having an excess of commitment to some special and constricting idea. . . . the intellectual function can be overwhelmed by an excess of piety expended within too contracted a frame of reference" (p. 29).

p. 80 ". . . as Monroe Beardsley suggests. . ."

See his "Aesthetic Experience," in *The Aesthetic Point of View*, ed. Wreen and Callen, op. cit., pp. 228-89.

". . . understood by Sir Roy Shaw . . ."

See his *Elitism versus Populism in the Arts* (Eastbourne: John Offord, n.d.). Also "The Arts Council and Aesthetic Education," *Journal of Aesthetic Education* 15, No. 3 (July 1981).

"Similarily, Hilton Kramer. . ."

See his remarks in *Conference on Art Criticism and Art Education*, ed. David W. Ecker, Jerome J. Hausman, and Irving Sandler (New York: Office of Field Research and School Services, New York University, n.d.), p. 23.

p. 81 ". . . a more eloquent case. . . than Robert Penn Warren. . ."

See his *Democracy & Poetry* (Cambridge: Harvard University Press, 1975).

". . . what Harold Osborne calls the expression of a univeral aesthetic impulse. . ."

See the Introduction to his *Aesthetics and Art Theory: An Historical Introduction* (New York: E. P. Dutton, 1970). Today, Osborne writes, many people believe "that the aesthetic motive has been operative throughout history to control the making and appraisal of those artifacts which we now regard as works of art even though it has been latent and unconscious. Though there was no explicit theory of aesthetic experience in classical antiquity or in the Middle Ages or at the Renaissance, works of art were fashioned meet for appreciation; and from the earliest human periods artifacts were made with formal qualities enabling us now to appreciate them aesthetically although these formal qualities—often far from easy to achieve—were redundant to their practical utility or to the religious, magical, or other functions which they were designed to fulfill" (p. 23). The unconscious operation of a natural aesthetic impulse which became self-conscious only in the modern era is one of the recurrent themes in Osborne's book.

John Walker, erstwhile director of the National Gallery of Art in Washington, D.C., supports Osborne's assumption. In writing about the great art treasures of the world—from a Yorubian bust of a king and the chalice of the Abbot Suger to a Byzantine ivory and a Sung Dynasty jade horse—he says that what enables them to accommodate each other's company is an "almost universally felt fitness between some transcendent value. . . and the utmost man can provide in the way of splendor, beauty, harmonious proportions and superb craftsmanship." From the introduction to Frank Getlein's *Art Treasures of the World* (New York: Clarkson N. Potter, 1968), p. 5.

p. 82 ". . . it is also 'a permanent possibility of experience' that. . ."

Warren, *Democracy and Poetry*, op. cit., p. 72.

". . . what Ortega y Gasset called the commonplace mind. . ."

See his *The Revolt of the Masses* (New York: W. W. Norton, 1932, p. 18. In *Man and His Circumstances: Ortega as Educator* (New York: Teachers College Press, 1971), Robert McClintock writes that Ortega's notion of the mass man is not necessarily one from the working classes but a person of any class who manifests a certain disposition. "The essential difference," says McClintock, "between a man of noble character and one of mass complacency was not in the type of actions that each undertook, but in the spirit with which each pursued outwardly similar acts: the noble man chose to make his deeds serve a demanding ideal, whereas the mass man was content if his acts satisfied his immediate appetites" (p. 336).

"Matthew Arnold also realized. . ."

For a discussion of Arnold's notion of the best self, see G. H. Bantock, *Studies in the History of Educational Theory*, vol. 2: *The Minds and the Masses, 1760-1980* (Boston: George Allen & Unwin, 1984), chap. 9.

5 Initiatives toward Excellence

The opening quotation is from Theodore R. Sizer, *Horace's Compromise: The Dilemma of the American High School* (Boston: Houghton Mifflin, 1984), p. 133.

Notes and references are placed under the book being discussed. Page numbers in parentheses refer to the text in question.

A Nation at Risk, op. cit.

p. 85 ". . . we read that knowledge of English, mathematics. . ." (pp. 24-25)

p. 86 ". . . further states 'that an over-emphasis on. . .' " (pp. 10-11)

"One objective of English study is. . ." (p. 25)

John Goodlad, *A Place Called School,* op. cit.

p. 87 Quotation beginning with "Those women—and men. . ." (p. 196)

p. 88 ". . . Goodlad nonetheless writes that. . ." (p. 361)

"Overall, says Goodlad,. . ." (p. 220)

p. 89 ". . . for contemporary progressive thinking about arts education. . ." (p. 375).

See Jerome J. Hausman, ed., *Arts and the Schools* (New York: McGraw-Hill, 1980).

Mortimer Adler, *The Paideia Proposal,* op. cit.

p. 90 ". . . that all children 'have the same. . .' " (p. 43)

p. 91 ". . . an additional treatment is required. . ." (pp. 30-32)

". . . the professional's fallacy. . ."

See Jacques Barzun, *The House of Intellect* (New York: Harper & Row, 1959). Barzun writes that "one can judge a building without knowing where to buy the bricks; one can understand a violin sonata without knowing how to score for the instrument. The work may in fact be better understood *without* a knowledge of the details of its manufacture, for attention to these tends to distract from meaning and effect" (pp. 11-12).

". . . conveniently overlooks the sad state of undergraduate education. . ."

See, e.g., William J. Bennett, *To Reclaim a Legacy: A Report on the Humanities in Higher Education* (Washington, D.C.: National Endowment for the Humanities, 1984).

Ernest Boyer, *High School,* op. cit.

p. 93 Quotation beginning with "Broadly defined. . ." (p. 96)

". . . even E. H. Gombrich. . ."

See his "The Visual Image: Its Place in Communication," in *The Image and the Eye* (Ithaca: Cornell University Press, 1982).

Theodore Sizer, *Horace's Compromise*, op. cit.

p. 95 Quotation beginning with "point of view throughout. . ." (p. 8)

"... take adolescents more seriously 'not out of some resurgence. . .' "
(p. 22)

p. 96 "... reminiscent of John Kenneth Galbraith's analysis. . ."

This is a persistent theme of the writings of John Kenneth Galbraith.
See his "The Market System and the Arts," in *Economics and the Public
Purpose* (Boston: Houghton Mifflin, 1973). Acknowledging the marginal
status of the arts in the national mentality, Galbraith writes that there can
be no doubt about the source of the attitudes: "It lies with the techno-
structure and the planning systems and with their ability to impose their
values on the society and the states. The technostructure embraces and
uses the engineer and the scientist; it cannot embrace the artist. Engineer-
ing and science serve its purpose; art, at its best, is something which it
needs but finds troublesome and puzzling. From these attitudes come
those of the community and the government. Engineering and science are
socially necessary; art is a luxury" (p. 66). Later on, however, he writes
that "there is no reason, a priori, to suppose that scientific and engineering
achievements serve the ultimate frontiers in human enjoyment. At some
point, as consumption expands, a transcending interest in beauty may be
expected. This transition will vastly alter both the character and structure
of the economic system" (p. 68).

p. 97 "... 'aesthetic expression and learning from others' attempts. . .' " (p. 133).

College Board, *Academic Preparation in the Arts*, op. cit.

p. 98 "... three kinds of knowledge. . . ."

The report states that significant progress should be made in the devel-
opment of three kinds of abilities:
"1. Knowledge of how to produce or perform works of art.
2. Knowledge of how to analyze, interpret, and evaluate artworks.
3. Knowledge of artworks of other periods and cultures and their con-
texts" (p. 20).

p. 99 "E. D. Hirsch, Jr., has described. . . ."

See his "Cultural Literacy," *The American Scholar* (Spring 1983).
Hirsch writes: "We shall need to restore certain common contents to the
humanities side of the school curriculum. But before we can make much
headway in that direction, we shall also need to modify the now-dominant
educational principle that holds that any suitable materials of instruction
can be used to teach the skills of writing and reading. I call this the doc-
trine of educational formalism" (p. 61). Might not the same reasoning
apply to the teaching of aesthetic, historical, and critical skills?

Harry S. Broudy, *Truth and Credibility: The Citizen's Dilemma* (New York: Long-
man, 1981).

p. 101 "It is as if Broudy borrowed his words directly from Saul Bellow's principal character. . ."

See Bellow's *The Dean's December* (New York: Harper & Row, 1982), p. 334.

p. 102 Quotation beginning with "The disciplines studied explicitly. . ." (p. 137).

p. 104 ". . . too little is done 'to empower students to perceive aesthetically. . .'"

Maxine Greene, "Aesthetic Literacy in General Education," in *Philosophy and Education*, ed. Jonas Soltis, Eightieth Yearbook of the National Society for the Study of Education, Part I (Chicago: University of Chicago Press, 1981), p. 118.

p. 105 ". . . the theoretical literature has moved away. . ."

See my "The Changing Image of Art Education: Theoretical Antecedents of Discipline-based Art Education," *Journal of Aesthetic Education* 21, No. 2 (Summer 1987), a special double issue devoted to discipline-based art education.

p. 106 ". . . to champion the arts as catalysts for general educational reform. . ."

These efforts are effectively criticized by Laura Chapman in her *Instant Art, Instant Culture* (New York: Teachers College Press, 1982).

". . . images of the field of art education no longer feature the child-artist. . ."

For two critical discussions of the place of child art in art education, see Arthur Efland, "The School Art Style: A Functional Analysis," *Studies in Art Education* 17, No. 2 (1976); and Margaret Klempay DiBlasio, "The Troublesome Concept of Child Art: A Threefold Analysis," *Journal of Aesthetic Education* 17, No. 3 (April 1983).

p. 107 "Perhaps no one has marked this distinction better than Frank Sibley."

See his "Aesthetic and Nonaesthetic," *The Philosophic Review* 74, No. 2 (April 1965). Sibley writes that "persons have to see the grace or unity of a work, hear the plaintiveness or frenzy in the music, notice the gaudiness of a color scheme, feel the power of a novel, its mood, or its uncertainty of tone. Persons may be struck by these qualities at once, or they may come to perceive them only after repeated viewings, hearings, or readings, and with the help of critics. But unless they do perceive them for themselves, aesthetic enjoyment, appreciation, and judgment are beyond them. Merely to learn, on good authority, that the music is serene, the play moving, or the picture unbalanced is of little aesthetic value; the crucial thing is to see, hear, or feel" (pp. 136-37).

"A number of writers have contributed substantively to the reconceptualization of the field of art education. . ."

A brief, which is to say by no means complete, representative bibliography consists of the following, limited mainly to books. Rudolf Arnheim, *Art and Visual Perception* (1954), second version (Berkeley: University of California Press, 1974); Manuel Barkan, *A Foundation for Art Education* (New York: Ronald Press, 1955); Thomas Munro, *Art Education: Its Philosophy and Psychology* (New York: Liberal Arts Press, 1956); Vincent Lanier, *Teaching Secondary Art* (Scranton: International Textbook, 1964); Ralph A. Smith, ed., *Aesthetics and Criticism in Art Education* (Chicago: Rand McNally, 1966); Elliot W. Eisner and David W. Ecker, eds., *Readings in Art Education* (Waltham, Mass.: Blaisdell, 1966); Reid Hastie, *Encounter with Art* (New York: McGraw-Hill, 1969); Edmund B. Feldman, *Becoming Human through Art* (Englewood Cliffs, N.J.: Prentice-Hall, 1970); George Pappas, ed., *Concepts in Art and Education* (New York: Macmillan, 1970); Ralph A. Smith, ed., *Aesthetics and Problems of Education* (Urbana: University of Illinois Press, 1971); David W. Ecker and Eugene F. Kaelin, "The Limits of Aesthetic Inquiry: A Guide to Educational Research," in *Philosophical Redirection of Educational Research*, ed. Laurence G. Thomas, Seventy-first Yearbook of the National Society for the Study of Education, Part I (Chicago: University of Chicago Press, 1972); Harry S. Broudy, *Enlightened Cherishing: An Essay on Aesthetic Education* (Urbana: University of Illinois Press, 1972); Elliot W. Eisner, *Educating Artistic Vision* (New York: Macmillan, 1972); Howard Gardner, *The Arts and Human Development* (New York: John Wiley, 1973); *Report of the NAEA Commission on Art Education* (Reston, Va.: National Art Education Association, 1977); Laura H. Chapman, *Approaches to Art in Education* (New York: Harcourt Brace Jovanovich, 1978); Charles D. Gaitskell, Al Hurwitz, and Michael Day, *Children and Their Art*, 4th ed. (New York: Harcourt Brace Jovanovich, 1982).

p. 108 ". . . policy statements of the National Art Education Association. . . ."

See its statement *Quality Art Education: An Interpretation* (Reston, Va.: National Art Education Association, 1986). Among other things, we read that content for art education should be drawn from the disciplines of aesthetics, art criticism, art history, and art production.

p. 111 ". . . is found in Leilani Lattin Duke's remarks. . ."

See her "Striving for Excellence in Art Education," *Design for the Arts in Education* 85, No. 3 (Jan./Feb. 1984). Also *Beyond Creating: The Place for Arts in America's Schools* (Los Angeles: The J. Paul Getty Trust, 1985).

". . . two Center-sponsored interpretations of discipline-based art education. . . ."

The first is an occasional paper by Elliot W. Eisner titled *The Role of Discipline-based Art Education in America's Schools* (Los Angeles: Getty Center for Education in the Arts, 1987); and the second, by far at the time of this writing the most systematic and comprehensive statement yet of the meaning of DBAE, an article by Gilbert A. Clark, Michael D. Day, and W. Dwaine Greer titled "Discipline-based Art Education: Becoming Students of Art," *Journal of Aesthetic Education* 21, No. 2 (Summer 1987).

p. 112 ". . . the new educational policy of the National Endowment for the Arts. . . ."

See *The New National Endowment for the Arts-in-Education Program: A Briefing Paper for the Arts Education Community* (Reston, Va: 1986). No publisher is given for the latter, but presumably it is available from the offices of the national art education associations (art, music, art and design, theater, and dance).

". . . the five-year program of the Rockefeller Brothers Fund. . ."

For descriptions of the program, see Lonna Jones, "Excellence in Arts Education: The Impulse to Search and to Know," *Design for the Arts in Education*, 85, No. 3 (Jan./Feb. 1984). The fifth year of the program was devoted to dissemination of the results of the programs. Also *Daedalus* 112, No. 3 (Summer 1983).

p. 113 ". . . hard put to find a baker's dozen."

See *Art History, Art Criticism, and Art Production: An Examination of Art Education in Selected School Districts*, 2 vols. (Santa Monica: Rand Corporation, 1984).

". . . the Alliance for Arts in Education. . . ."

See its pamphlet *Performing Together: The Arts and Education* (Arlington, Va.: American Association of School Administrators, n.d.).

Postscript

p. 117 The two reports in question are: *A Nation Prepared: Teachers for the 21st Century*, the Report of the Task Force on Teaching as a Profession (Hyattsville, Md.: Carnegie Forum on Education and the Economy, 1986); and *Tomorrow's Teachers: A Report of the Holmes Group* (East Lansing: Holmes Group, Inc., 1986).

p. 118 ". . . more art specialists."

See *A Nation Prepared*, pp. 73-74. The importance of teaching the arts at the elementary level is stressed in William J. Bennett, *First Lessons: A Report on Elementary Education in America* (Washington, D.C.: Government Printing Office, 1986), pp. 35-36.